THE
ALCHEMIST

A GRAPHIC NOVEL

THE
ALCHEMIST

A GRAPHIC NOVEL

PAULO COELHO

HarperOne
An Imprint of HarperCollins*Publishers*

HarperOne

HarperCollins books may be purchased for educational, business, or sales promotional use. For information please write: Special Markets Department, HarperCollins Publishers, 10 East 53rd Street, New York, NY 10022.

HarperCollins website: http://www.harpercollins.com

HarperCollins®, 📖®, and HarperOne™ are trademarks of HarperCollins Publishers.

FIRST EDITION

Library of Congress Cataloging-in-Publication Data is available upon request. ISBN 978–0–06–202432–9

10 11 12 13 14 RRD(H) 10 9 8 7 6 5 4 3 2 1

PAULO COELHO

30 Setembro 2010

It was an old dream of mine to have The Alchemist as a graphic novel. I had received several proposals but none of them came anywhere near the classical vision I have in my mind for a graphic format. When I saw Sea Lion Books' proposal however it took me less than half an hour to make my decision. And I must admit that I am very thrilled that I had gone with my instincts to go with them instead of another.

From the first page to the last, I have been enthralled by the superior work from Sea Lion Books and kept on the edge of my seat. Santiago just seemed to spring to life right before my eyes, as well as all the other characters from The Alchemist. I was honored when David Dabel asked me if I would mind if the King of Salem could bear my resemblance. I had not foreseen that I would star in the graphic novel, but it was a very pleasant surprise.

To those who've read The Alchemist novel before, you will soon discover the graphic novel does not lose the essence of the story at all, but in fact enhances upon it visually. If, however, you are a first time reader, I do hope you enjoy Santiago's journey. Thanks.

Sincerely Yours,
Paulo Coelho

DANIEL SAMPERE

When my manager told me if I would draw the graphic novel of The Alchemist, the first thing I thought was "The Alchemist?" there's no action on The Alchemist or super heroes! I've always drawn action comics. Then I started thinking, and I felt a lot of pressure. The Alchemist is one of the most important best sellers in history with million of fans, and I knew that it was going to be a really good challenge for me.

When I started working on the pages, the magic of the book quickly invaded me, and I started enjoying drawing desert scenes, really beautiful landscapes. I think when you read the novel, you get a very relaxed feeling, it just calms you in a very good way and that was really difficult to transmit all those feelings on the pages. I tried to create an art style that would transmit this sensation that the original book gave you.

It's been a really difficult and stressful experience too, but all the hard work I put into the pages were worth it. I'm very happy because I worked with a really great team, the inkers, and the colorists impressed me. The entire creative team did amazing work.

The Alchemist talks about personal legends, and to follow your dreams. It is an invitation for everyone to fight for what you want in life without any fear. That's why I want to dedicate this book to my grandfather, because he was the person who inspired me to be a comic book artist and the person who taught me, and encouraged me to fight to follow my dream. Without him, I would never have become an artist. To the memory of my grandpa, the best artist I've ever met

Daniel Sampere

Daniel Sampere

DEREK RUIZ

If feels like only yesterday that David Dabel brought "The Alchemist" to my attention. Up until that point I never heard of "The Alchemist" or its wonderful message, so reading it was very enlightening. You see, the book tells you that everything on the planet has a Personal Legend. A Personal Legend is what you always wanted to accomplish in your life. You usually know what your Personal Legend is when you are younger. When you are younger you believe all your dreams can become a reality, because they can. Young people are usually described as fearless dreamers. I would rather be a dreamer than someone who just settles for what is easy in life. Since I was eight years old I have wanted to work in the comic book industry. Working in the comic industry and being successful at it has been my Personal Legend. I have had my ups and downs just like Santiago. There have been times where I've wanted to give it all up but my heart wouldn't let it. It would whisper to me that things will get better and all your struggles will pay off. Finally with Sea Lion Books I feel like I've reached a place where my dreams are finally going to be fulfilled and getting to the end of my Personal Legend is finally at hand.

I want to dedicate this book to my mother and father for always telling me to follow my dreams because they will never let me down. I would also like to thank my family and friends for being very supportive while I was hard at work on adapting this book. You guys are the best!
Finally I want to thank Paulo Coelho for writing this work of art that makes clear what we all should know about life.
Never Give Up On Your Dreams.

Derek Ruiz

Derek Ruiz

A Special

Thank You

To:

Paulo Coelho
Mônica R. Antunes
Gideon Weil
Joaquin Garcia
Giovani Kososki
Dave Lanphear
Silvia Ebens
Gemma Capdevila
Daniel Sampere
Fernando Leon
Romulo Soares and Lynx Studio
Shon C. Bury and Xavi Marturet of Space Goat Productions
Klebs Junior and Impacto Studio
Nelson Cosentino De Oliveira
Carlos Eduardo
Jake Bilbao
Ernst Dabel Sr.
Jorge Correa Jr
Mauricio Melo
Troy Peteri
Vitor Ishimura
Tony Kordos
Anderson Garcia
Kuo-Yu Liang
Waki
Josh Templeton
Mohan
IGF (Sunny Gho)
Shefali
Bill Tortolini
Digikore
Izrael

THE ALCHEMIST

written by:

PAULO COELHO

adapted by:

DEREK RUIZ

artwork by:

DANIEL SAMPERE

and

Others

Sea Lion Books
www.sealionbooks.com

HarperOne
www.harpercollins.com

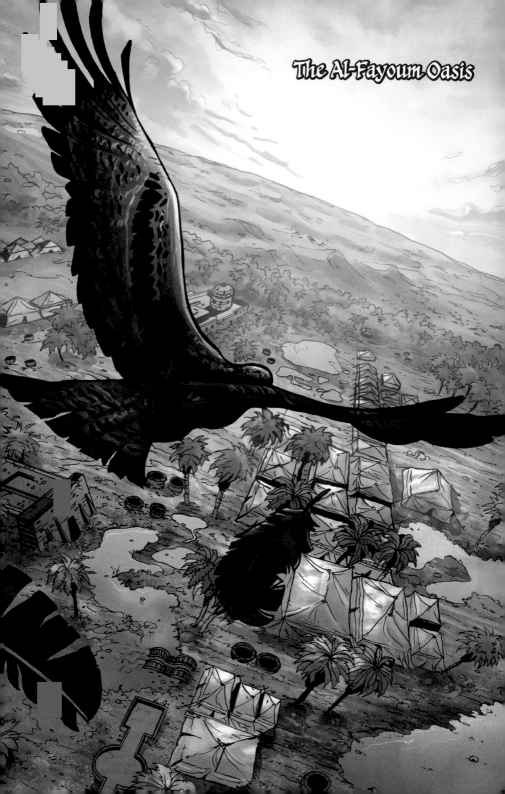

The Al-Fayoum Oasis

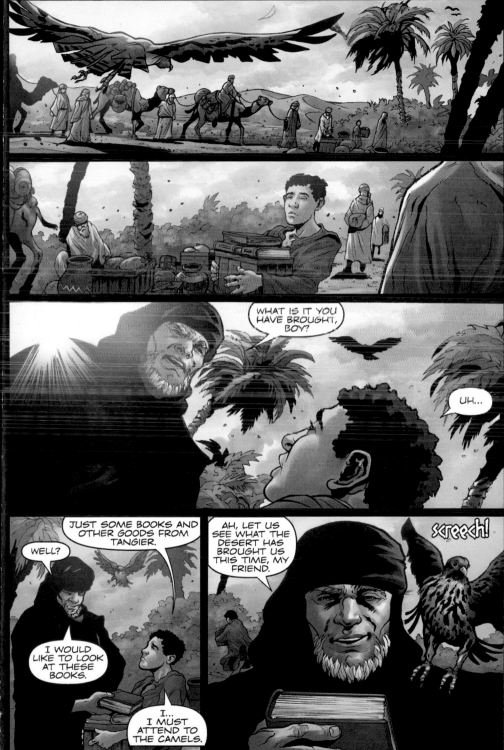

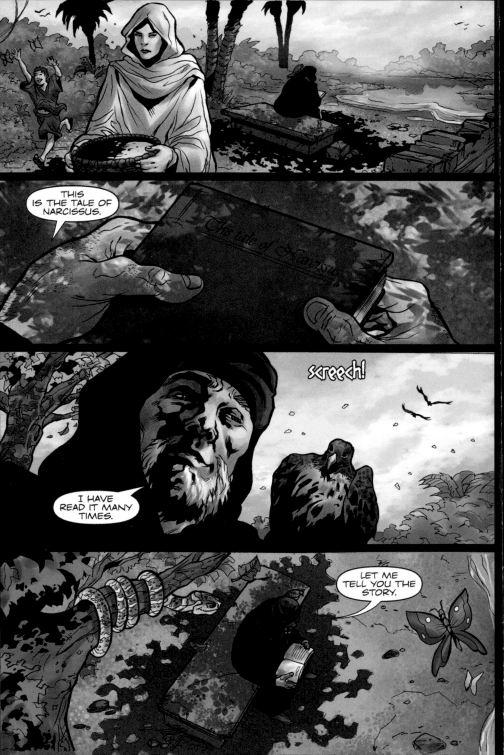

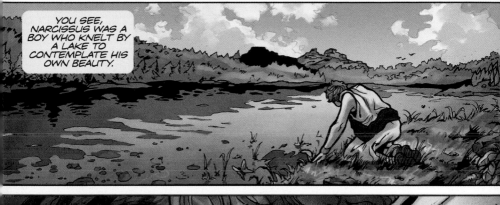

YOU SEE, NARCISSUS WAS A BOY WHO KNELT BY A LAKE TO CONTEMPLATE HIS OWN BEAUTY.

HE WAS SO FASCINATED BY HIMSELF THAT ONE MORNING...

...HE FELL INTO THE LAKE...

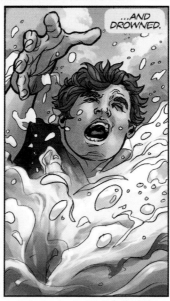

...AND DROWNED.

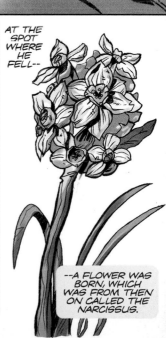

AT THE SPOT WHERE HE FELL--

--A FLOWER WAS BORN, WHICH WAS FROM THEN ON CALLED THE NARCISSUS.

AH HA. LOOK, MY FRIEND, THIS VERSION ADDS MORE TO THE STORY.

IT SAYS HERE...

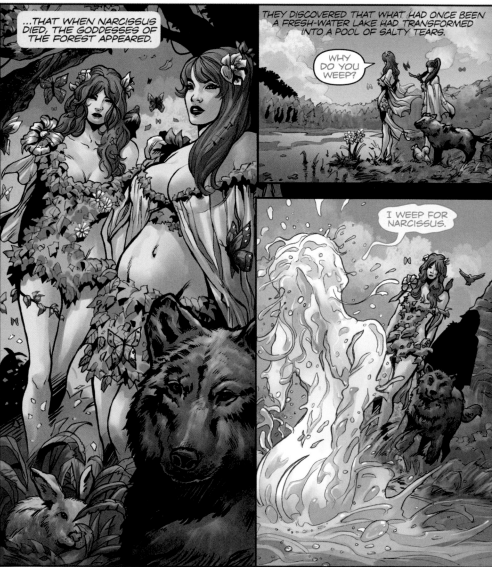

...THAT WHEN NARCISSUS DIED, THE GODDESSES OF THE FOREST APPEARED.

THEY DISCOVERED THAT WHAT HAD ONCE BEEN A FRESH-WATER LAKE HAD TRANSFORMED INTO A POOL OF SALTY TEARS.

WHY DO YOU WEEP?

I WEEP FOR NARCISSUS.

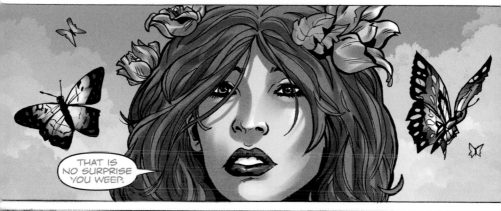

THAT IS NO SURPRISE YOU WEEP.

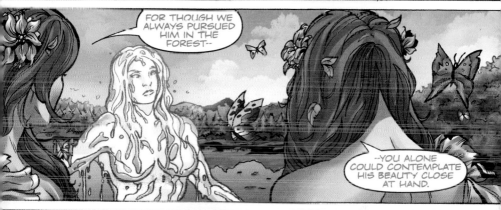

FOR THOUGH WE ALWAYS PURSUED HIM IN THE FOREST--

--YOU ALONE COULD CONTEMPLATE HIS BEAUTY CLOSE AT HAND.

BUT... WAS NARCISSUS BEAUTIFUL?

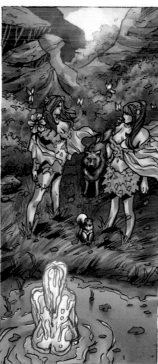

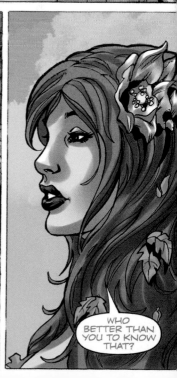

WHO BETTER THAN YOU TO KNOW THAT?

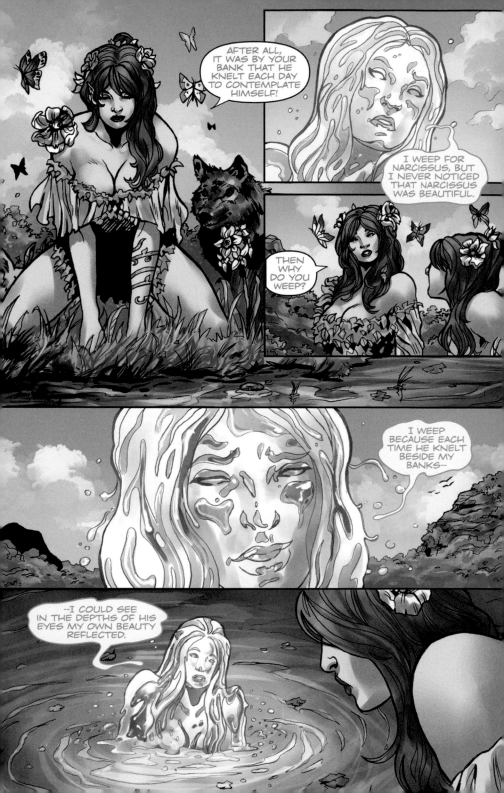

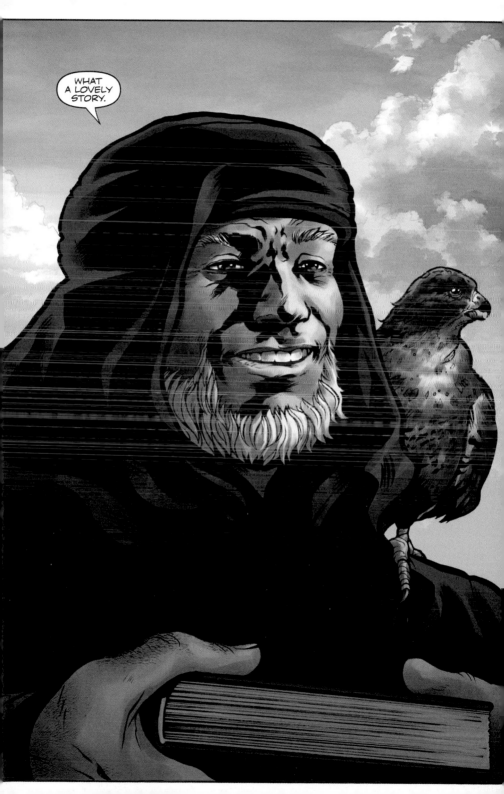

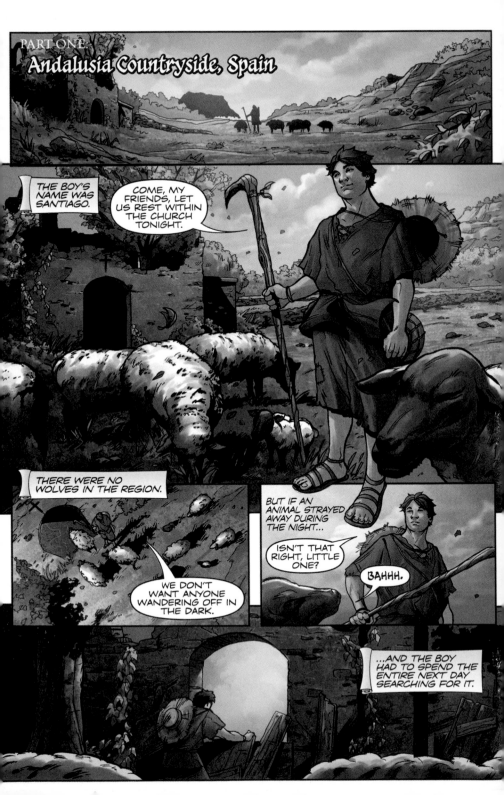

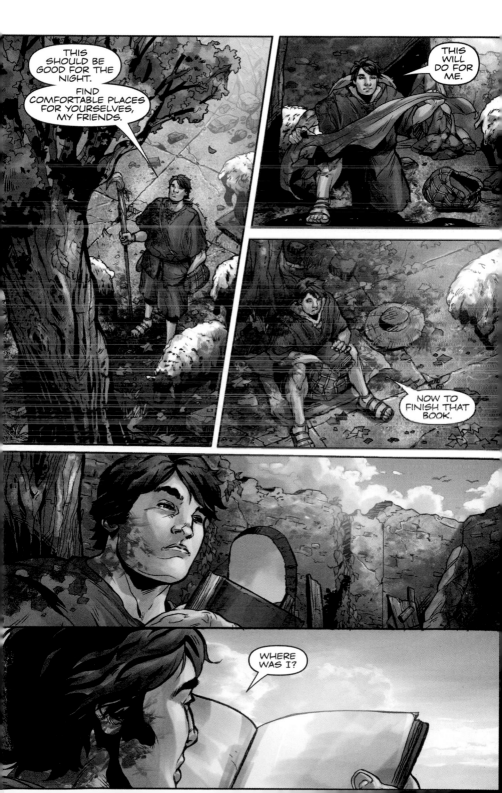

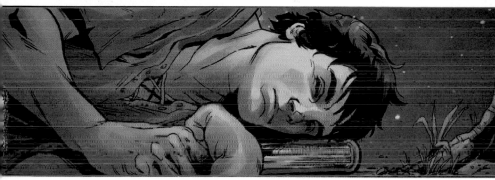

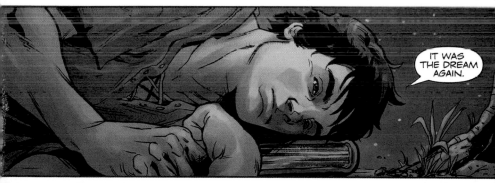

IT WAS THE DREAM AGAIN.

WHY CAN I NOT SEE THE END OF THIS DREAM?

BAHHH.

YOU MUST BE GETTING USED TO MY SCHEDULE, MY FRIENDS.

OR MAYBE I AM GETTING USED TO YOURS!

FELIPE! WAKE UP, LAZYHEAD.

YOU ALWAYS TRY TO SLEEP LONGER THAN THE REST.

HE CALLED EACH SHEEP BY NAME...

...FELIPE, ALBA, MARIA, FRANCISCO...

IT IS TIME TO HEAD TO THE FIELDS.

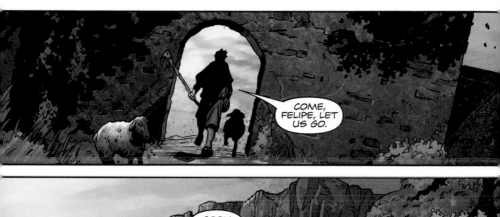

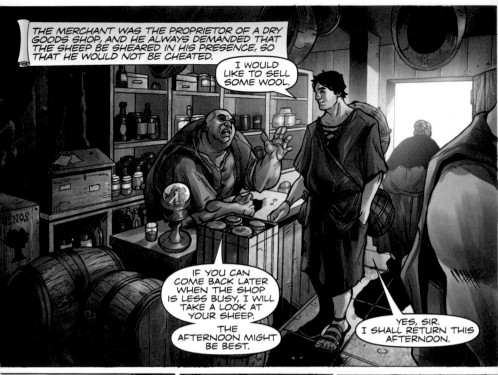

THE MERCHANT WAS THE PROPRIETOR OF A DRY GOODS SHOP, AND HE ALWAYS DEMANDED THAT THE SHEEP BE SHEARED IN HIS PRESENCE, SO THAT HE WOULD NOT BE CHEATED.

I WOULD LIKE TO SELL SOME WOOL.

IF YOU CAN COME BACK LATER WHEN THE SHOP IS LESS BUSY, I WILL TAKE A LOOK AT YOUR SHEEP.

THE AFTERNOON MIGHT BE BEST.

YES, SIR. I SHALL RETURN THIS AFTERNOON.

MIGHT AS WELL CATCH UP ON SOME READING.

I DIDN'T KNOW SHEPHERDS KNEW HOW TO READ.

WELL...I... ...UH.

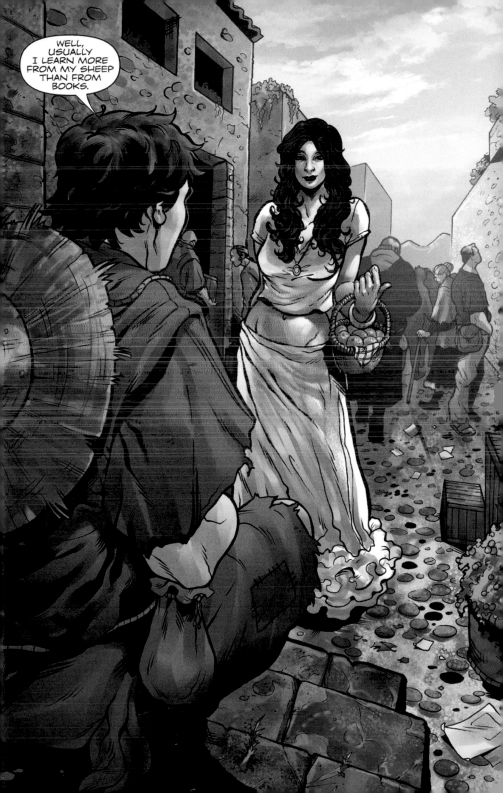

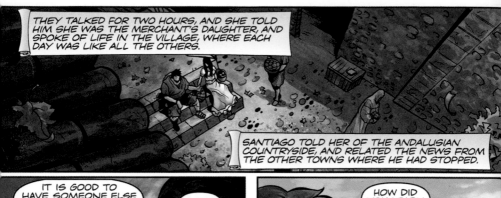

THEY TALKED FOR TWO HOURS, AND SHE TOLD HIM SHE WAS THE MERCHANT'S DAUGHTER, AND SPOKE OF LIFE IN THE VILLAGE, WHERE EACH DAY WAS LIKE ALL THE OTHERS.

SANTIAGO TOLD HER OF THE ANDALUSIAN COUNTRYSIDE, AND RELATED THE NEWS FROM THE OTHER TOWNS WHERE HE HAD STOPPED.

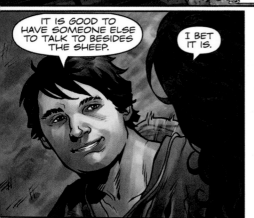

IT IS GOOD TO HAVE SOMEONE ELSE TO TALK TO BESIDES THE SHEEP.

I BET IT IS.

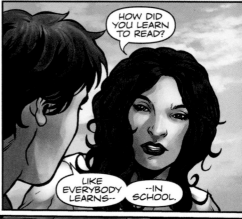

HOW DID YOU LEARN TO READ?

LIKE EVERYBODY LEARNS--

--IN SCHOOL.

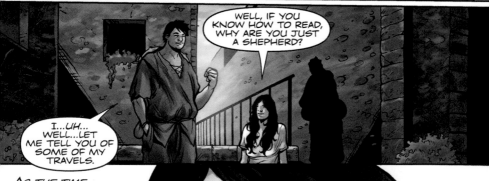

WELL, IF YOU KNOW HOW TO READ, WHY ARE YOU JUST A SHEPHERD?

I...UH... WELL...LET ME TELL YOU OF SOME OF MY TRAVELS.

AS THE TIME PASSED, THE BOY FOUND HIMSELF WISHING THAT THE DAY WOULD NEVER END, THAT HER FATHER WOULD STAY BUSY AND KEEP HIM WAITING FOR THREE DAYS.

HE RECOGNIZED THAT HE WAS FEELING SOMETHING HE HAD NEVER EXPERIENCED BEFORE: THE DESIRE TO LIVE IN ONE PLACE FOREVER.

WITH THE GIRL WITH THE RAVEN HAIR, HIS DAYS WOULD NEVER BE THE SAME AGAIN.

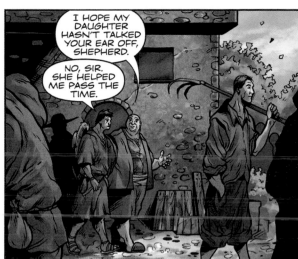

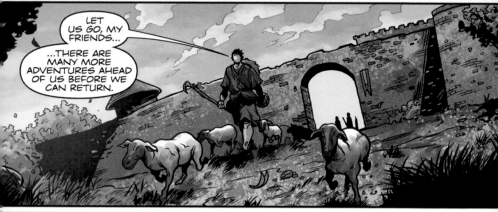

FOUR MORE DAYS AND I'LL BE ABLE TO TALK TO THE MERCHANT'S DAUGHTER AGAIN.

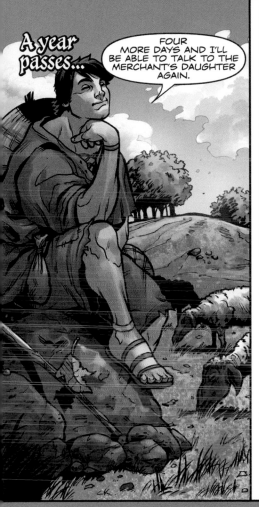

HOPEFULLY, NO OTHER SHEPHERDS HAVE WON HER HEART.

NOT THAT IT MATTERS.

I KNOW OTHER GIRLS IN OTHER PLACES.

BUT HIS HEART KNEW THAT IT DID MATTER.

HE KNEW THAT SHEPHERDS, LIKE SEAMEN AND TRAVELING SALESMEN, ALWAYS FOUND A TOWN WHERE THERE WAS SOMEONE TO MAKE THEM FORGET THE JOYS OF CAREFREE WANDERING.

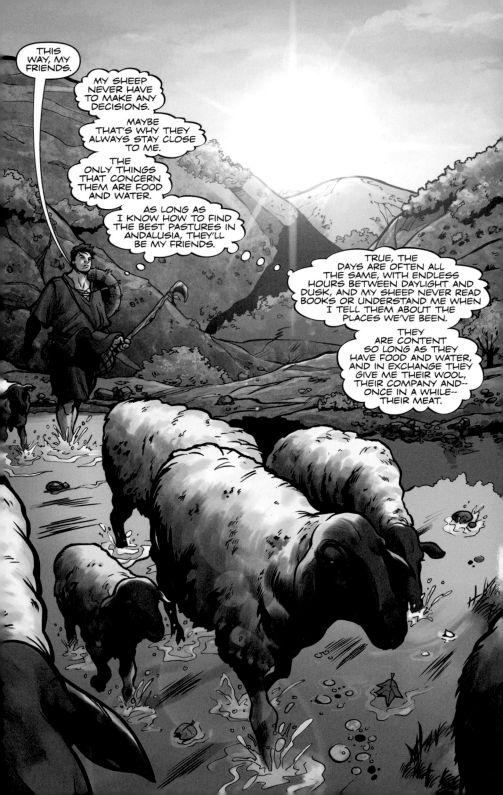

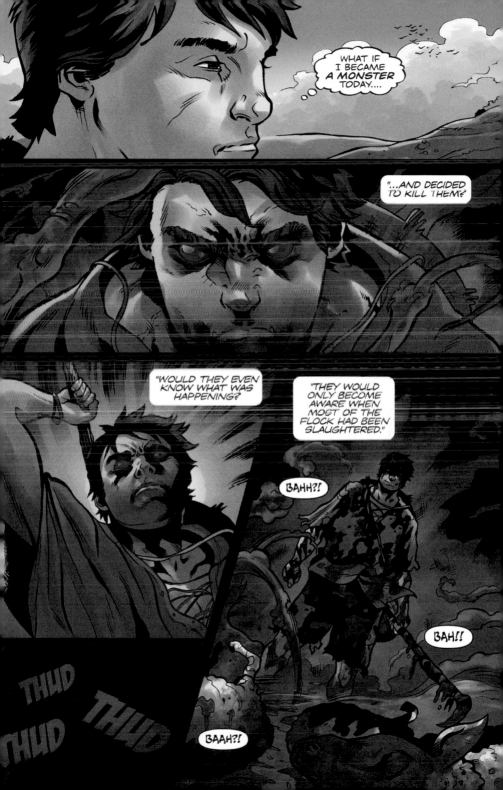

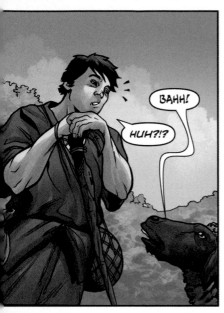

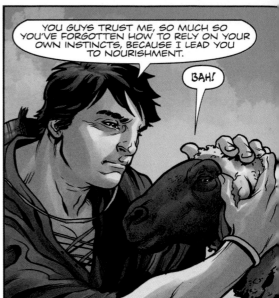

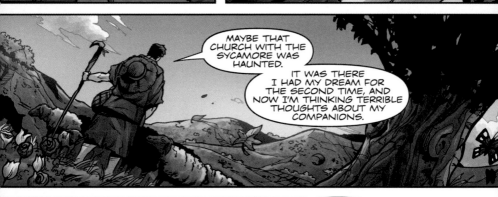

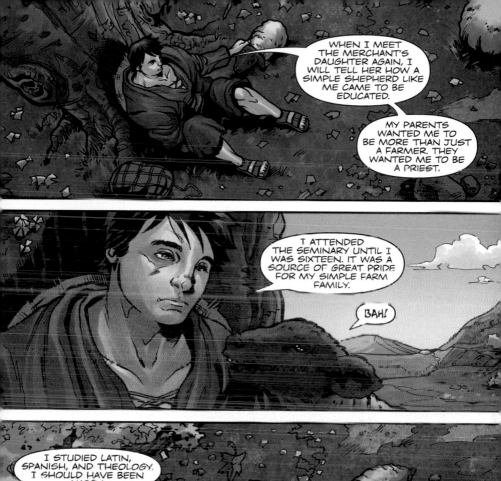

WHEN I MEET THE MERCHANT'S DAUGHTER AGAIN, I WILL TELL HER HOW A SIMPLE SHEPHERD LIKE ME CAME TO BE EDUCATED.

MY PARENTS WANTED ME TO BE MORE THAN JUST A FARMER. THEY WANTED ME TO BE A PRIEST.

I ATTENDED THE SEMINARY UNTIL I WAS SIXTEEN. IT WAS A SOURCE OF GREAT PRIDE FOR MY SIMPLE FARM FAMILY.

BAH!

I STUDIED LATIN, SPANISH, AND THEOLOGY. I SHOULD HAVE BEEN HAPPY.

BUT EVER SINCE I WAS A CHILD I WANTED TO KNOW THE WORLD.

I THOUGHT SEEING THE WORLD WAS MORE IMPORTANT THAN KNOWING GOD AND LEARNING OF MAN'S SINS.

SO ON A VISIT HOME TWO YEARS AGO, I TOLD MY FATHER I WANTED TO TRAVEL.

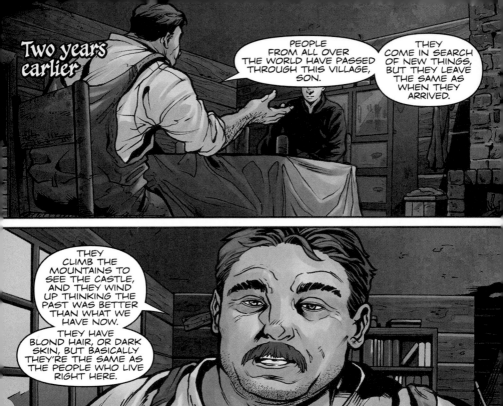

Two years earlier

PEOPLE FROM ALL OVER THE WORLD HAVE PASSED THROUGH THIS VILLAGE, SON.

THEY COME IN SEARCH OF NEW THINGS, BUT THEY LEAVE THE SAME AS WHEN THEY ARRIVED.

THEY CLIMB THE MOUNTAINS TO SEE THE CASTLE, AND THEY WIND UP THINKING THE PAST WAS BETTER THAN WHAT WE HAVE NOW.

THEY HAVE BLOND HAIR, OR DARK SKIN, BUT BASICALLY THEY'RE THE SAME AS THE PEOPLE WHO LIVE RIGHT HERE.

BUT I'D LIKE TO SEE THE CASTLES IN THE TOWNS WHERE THEY LIVE.

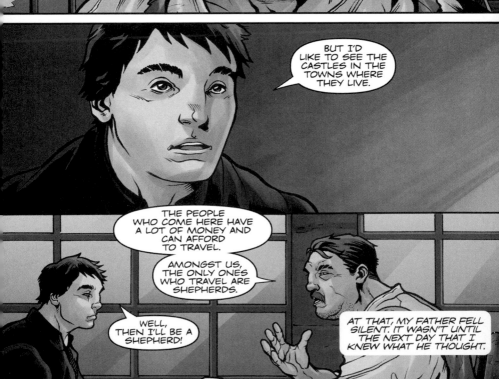

THE PEOPLE WHO COME HERE HAVE A LOT OF MONEY AND CAN AFFORD TO TRAVEL.

AMONGST US, THE ONLY ONES WHO TRAVEL ARE SHEPHERDS.

WELL, THEN I'LL BE A SHEPHERD!

AT THAT, MY FATHER FELL SILENT. IT WASN'T UNTIL THE NEXT DAY THAT I KNEW WHAT HE THOUGHT.

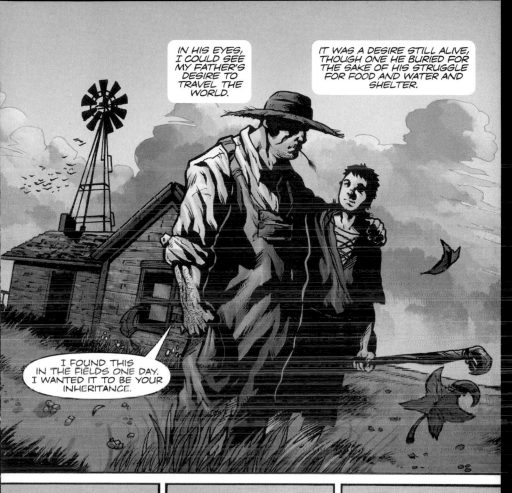

IN HIS EYES, I COULD SEE MY FATHER'S DESIRE TO TRAVEL THE WORLD.

IT WAS A DESIRE STILL ALIVE, THOUGH ONE HE BURIED FOR THE SAKE OF HIS STRUGGLE FOR FOOD AND WATER AND SHELTER.

I FOUND THIS IN THE FIELDS ONE DAY. I WANTED IT TO BE YOUR INHERITANCE.

BUT USE THEM TO BUY YOUR FLOCK.

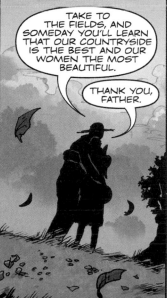

TAKE TO THE FIELDS, AND SOMEDAY YOU'LL LEARN THAT OUR COUNTRYSIDE IS THE BEST AND OUR WOMEN THE MOST BEAUTIFUL.

THANK YOU, FATHER.

HE GAVE ME HIS BLESSING, AND I WAS ON MY WAY TO BEGINNING A LIFE AS A SHEPHERD.

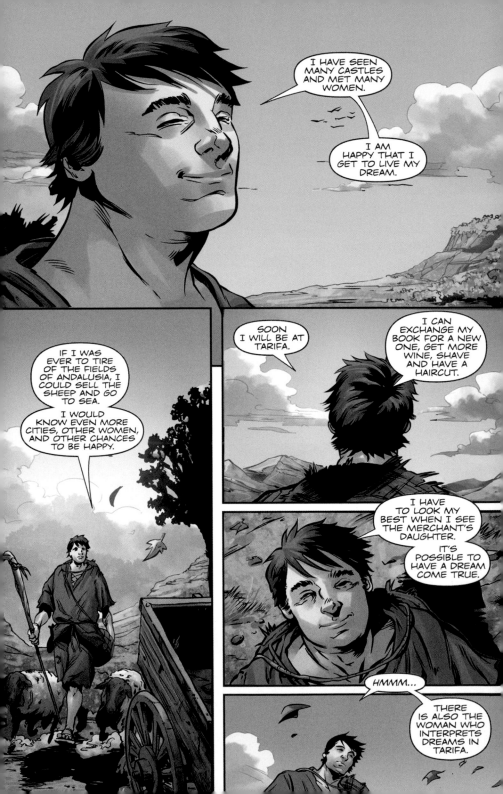

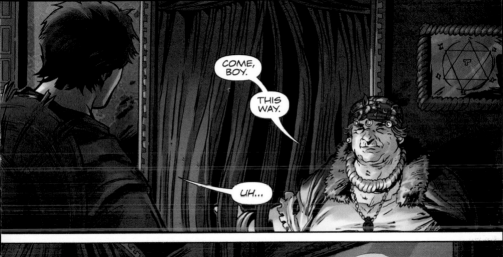

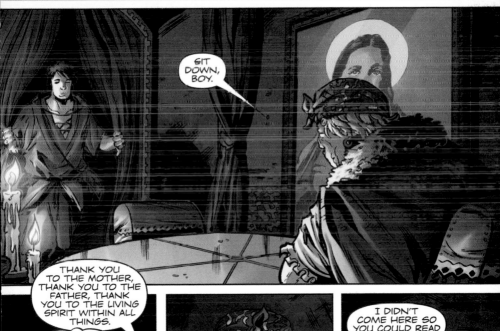

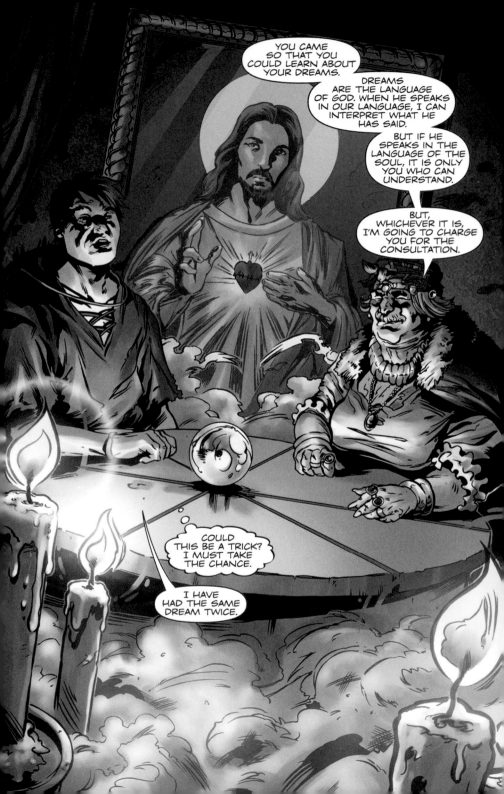

"I AM IN THE FIELDS WITH MY SHEEP.

"A CHILD APPEARS AND BEGINS TO PLAY WITH THE ANIMALS. I DON'T LIKE THAT. THE SHEEP ARE OFTEN AFRAID OF STRANGERS.

"BUT CHILDREN DON'T FRIGHTEN THEM. I DON'T KNOW HOW THEY KNOW THE DIFFERENT AGES OF HUMAN BEINGS."

HHHHM. INTERESTING, BUT I SUGGEST YOU SKIP THE SMALL DETAILS.

AND YOU DON'T HAVE MUCH MONEY, SO I CAN'T GIVE YOU A LOT OF MY TIME.

"WELL...OKAY. THE CHILD WENT ON PLAYING WITH THE SHEEP AS I APPROACHED.

"SUDDENLY, SHE TURNED AND PLACED HER HANDS ON ME, AND WE WERE TRANSPORTED..."

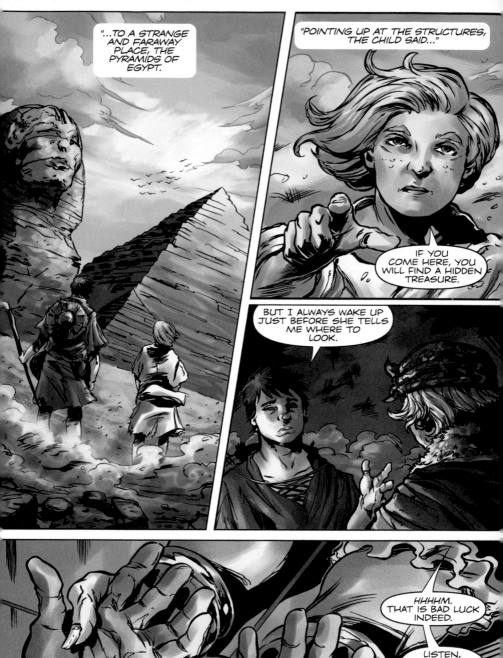

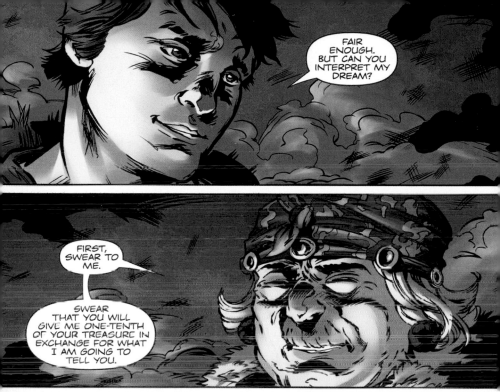

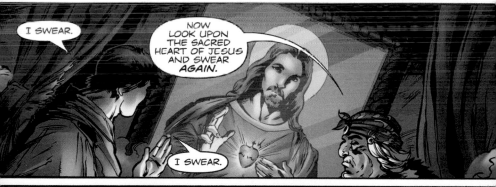

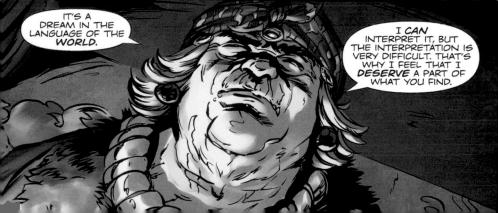

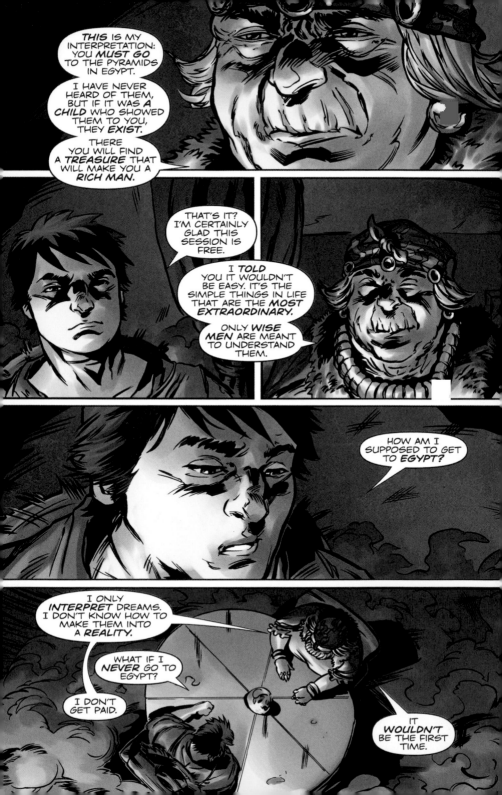

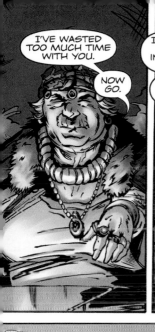

I'VE WASTED TOO MUCH TIME WITH YOU.

NOW GO.

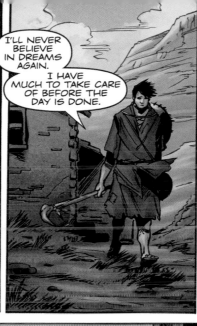

I'LL NEVER BELIEVE IN DREAMS AGAIN.

I HAVE MUCH TO TAKE CARE OF BEFORE THE DAY IS DONE.

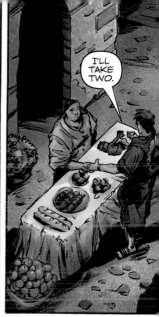

I'LL TAKE TWO.

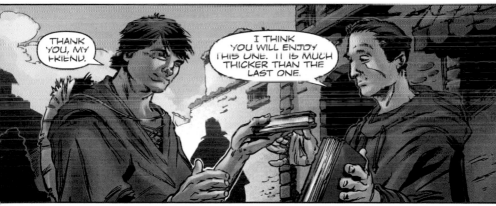

THANK YOU, MY FRIEND.

I THINK YOU WILL ENJOY THIS ONE. IT IS MUCH THICKER THAN THE LAST ONE.

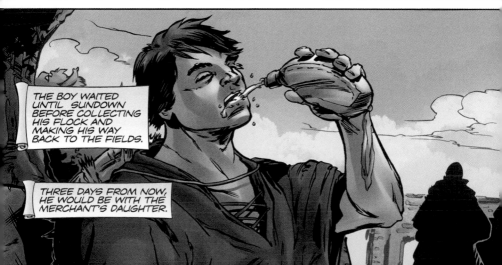

THE BOY WAITED UNTIL SUNDOWN BEFORE COLLECTING HIS FLOCK AND MAKING HIS WAY BACK TO THE FIELDS.

THREE DAYS FROM NOW, HE WOULD BE WITH THE MERCHANT'S DAUGHTER.

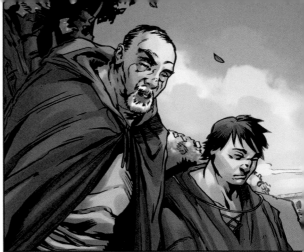

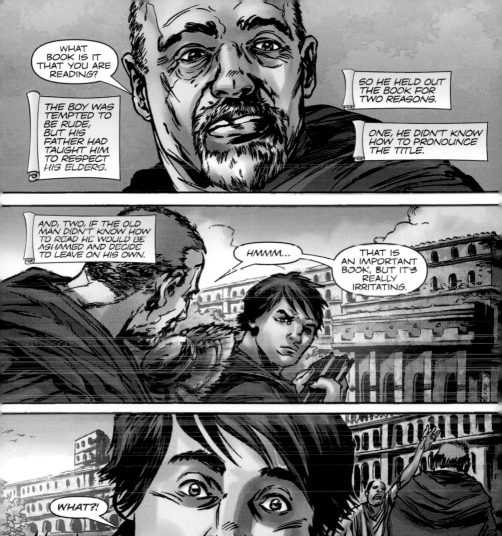

WHAT BOOK IS IT THAT YOU ARE READING?

THE BOY WAS TEMPTED TO BE RUDE, BUT HIS FATHER HAD TAUGHT HIM TO RESPECT HIS ELDERS.

SO HE HELD OUT THE BOOK FOR TWO REASONS.

ONE, HE DIDN'T KNOW HOW TO PRONOUNCE THE TITLE.

AND, TWO, IF THE OLD MAN DIDN'T KNOW HOW TO READ HE WOULD BE ASHAMED AND DECIDE TO LEAVE ON HIS OWN.

HMMM...

THAT IS AN IMPORTANT BOOK, BUT IT'S REALLY IRRITATING.

WHAT?!

YOU KNOW OF THIS BOOK?

YES.

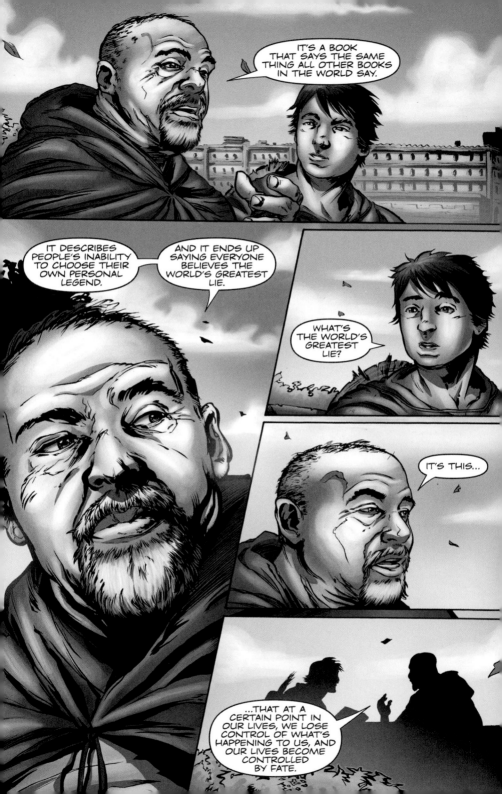

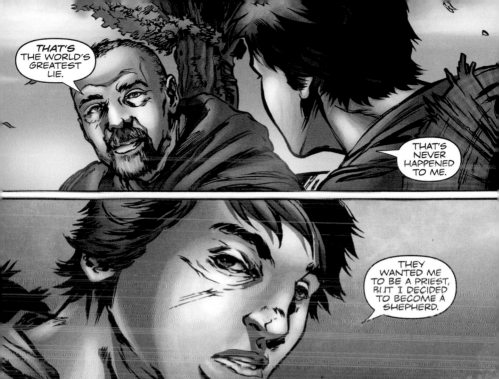

THAT'S THE WORLD'S GREATEST LIE.

THAT'S NEVER HAPPENED TO ME.

THEY WANTED ME TO BE A PRIEST, BUT I DECIDED TO BECOME A SHEPHERD.

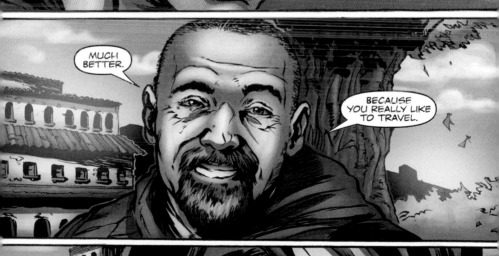

MUCH BETTER.

BECAUSE YOU REALLY LIKE TO TRAVEL.

HE KNOWS WHAT I AM THINKING!

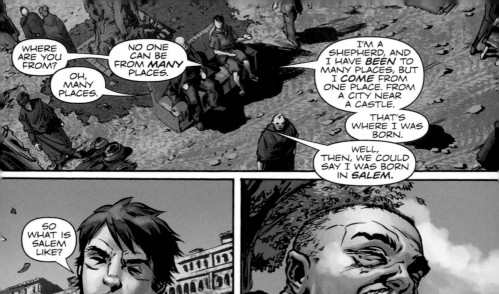

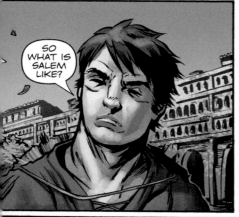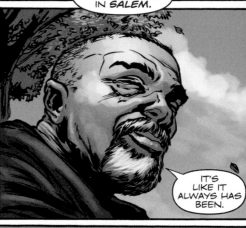

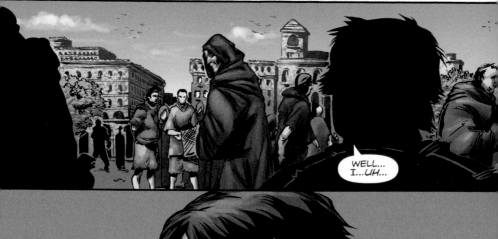

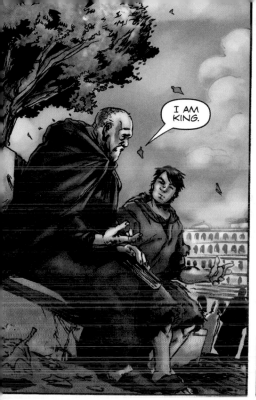

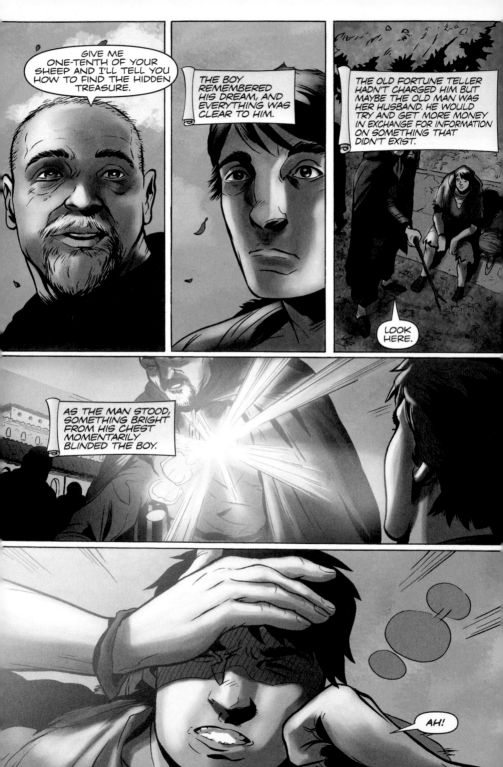

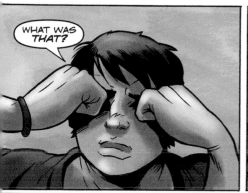

WHAT WAS THAT?

I... OH, MY...

WRITTEN IN THE SAND OF THE PLAZA WERE THE NAMES OF HIS FATHER AND MOTHER.

ALSO WRITTEN WAS THE NAME OF THE SEMINARY HE HAD ATTENDED. AND EVEN THE NAME OF THE MERCHANT'S DAUGHTER WHICH HE HADN'T KNOWN YET.

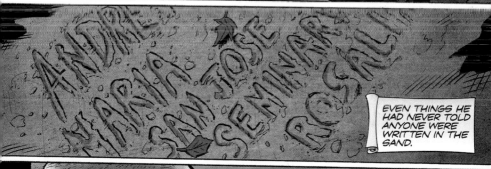

EVEN THINGS HE HAD NEVER TOLD ANYONE WERE WRITTEN IN THE SAND.

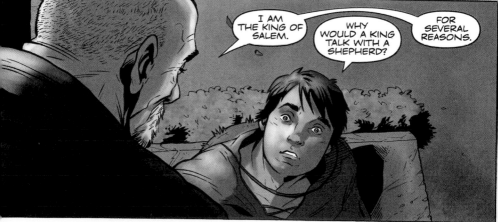

I AM THE KING OF SALEM.

WHY WOULD A KING TALK WITH A SHEPHERD?

FOR SEVERAL REASONS.

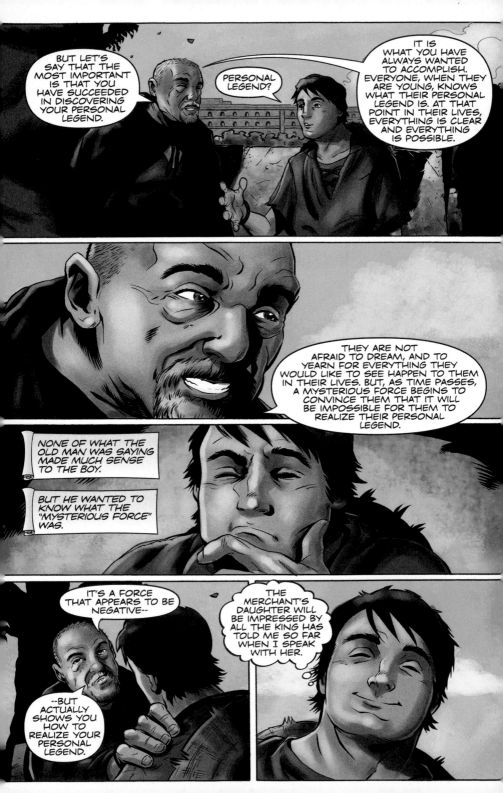

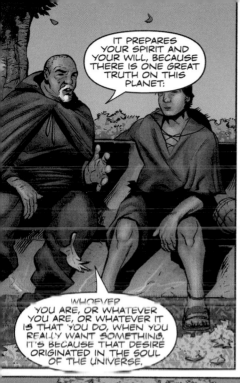

IT PREPARES YOUR SPIRIT AND YOUR WILL, BECAUSE THERE IS ONE GREAT TRUTH ON THIS PLANET:

WHOEVER YOU ARE, OR WHATEVER YOU ARE, OR WHATEVER IT IS THAT YOU DO, WHEN YOU REALLY WANT SOMETHING, IT'S BECAUSE THAT DESIRE ORIGINATED IN THE SOUL OF THE UNIVERSE.

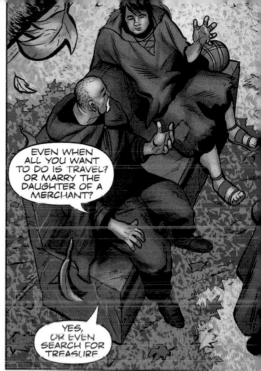

EVEN WHEN ALL YOU WANT TO DO IS TRAVEL? OR MARRY THE DAUGHTER OF A MERCHANT?

YES, OR EVEN SEARCH FOR TREASURE.

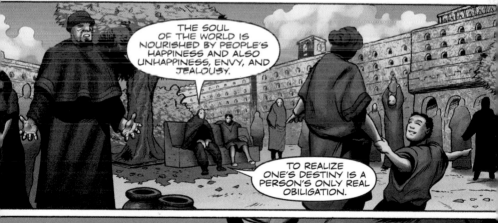

THE SOUL OF THE WORLD IS NOURISHED BY PEOPLE'S HAPPINESS AND ALSO UNHAPPINESS, ENVY, AND JEALOUSY.

TO REALIZE ONE'S DESTINY IS A PERSON'S ONLY REAL OBLIGATION.

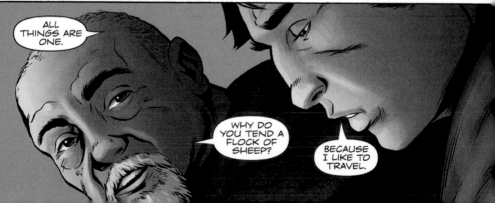

ALL THINGS ARE ONE.

WHY DO YOU TEND A FLOCK OF SHEEP?

BECAUSE I LIKE TO TRAVEL.

YOU SEE THAT BAKER?

WHEN HE WAS A CHILD, THAT MAN WANTED TO TRAVEL, TOO.

BUT HE DECIDED FIRST TO BUY HIS BAKERY AND PUT SOME MONEY ASIDE.

WHEN HE'S AN OLD MAN, HE'S GOING TO SPEND A MONTH IN AFRICA.

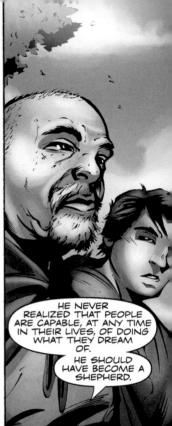

HE NEVER REALIZED THAT PEOPLE ARE CAPABLE, AT ANY TIME IN THEIR LIVES, OF DOING WHAT THEY DREAM OF.

HE SHOULD HAVE BECOME A SHEPHERD.

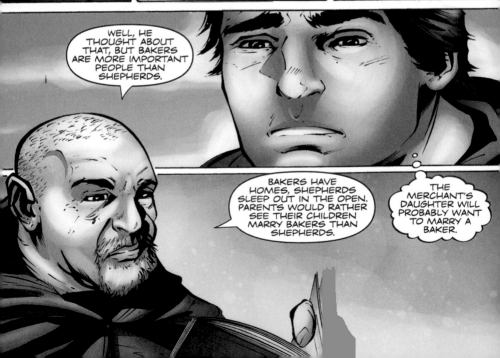

WELL, HE THOUGHT ABOUT THAT, BUT BAKERS ARE MORE IMPORTANT PEOPLE THAN SHEPHERDS.

BAKERS HAVE HOMES, SHEPHERDS SLEEP OUT IN THE OPEN. PARENTS WOULD RATHER SEE THEIR CHILDREN MARRY BAKERS THAN SHEPHERDS.

THE MERCHANT'S DAUGHTER WILL PROBABLY WANT TO MARRY A BAKER.

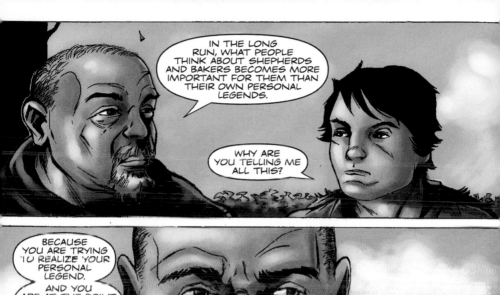

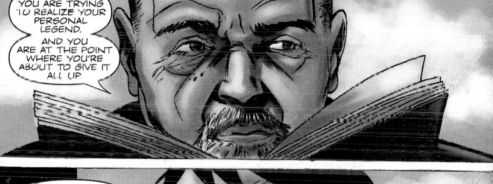

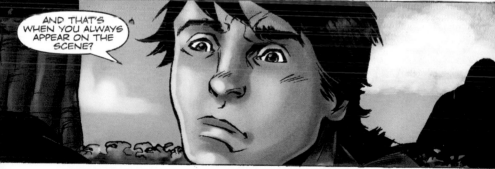

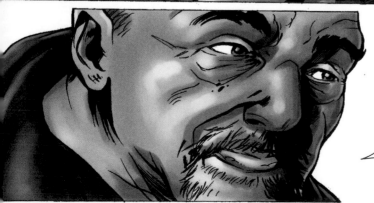

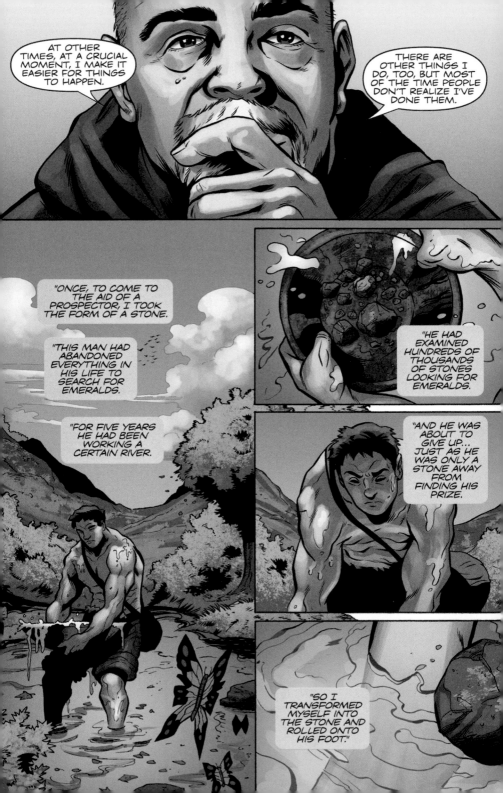

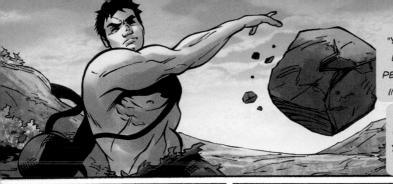

"YOU SEE, HE HAD SACRIFICED EVERYTHING TO SEEK HIS PERSONAL LEGEND SO I HAD TO INVOLVE MYSELF.

"IN HIS ANGER AND THE FRUSTRATION OF FIVE FRUITLESS YEARS, HE PICKED UP THE STONE I HAD BECOME...

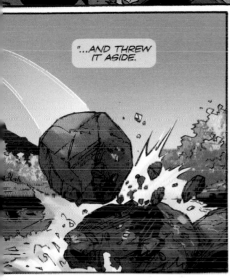

"...AND THREW IT ASIDE.

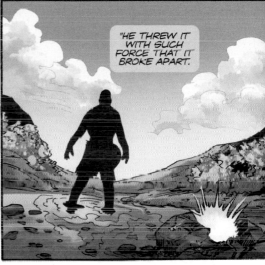

"HE THREW IT WITH SUCH FORCE THAT IT BROKE APART.

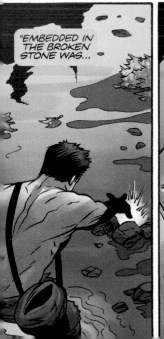

"EMBEDDED IN THE BROKEN STONE WAS...

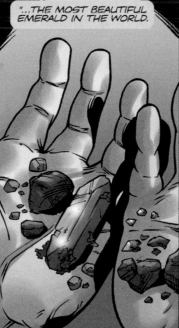

"...THE MOST BEAUTIFUL EMERALD IN THE WORLD.

"PEOPLE LEARN, EARLY IN THEIR LIVES, WHAT IS THEIR REASON FOR BEING."

MAYBE THAT'S WHY THEY GIVE UP ON IT SO EARLY, TOO. BUT THAT'S THE WAY IT IS.

YOU SAID SOMETHING ABOUT HIDDEN TREASURE?

TREASURE IS UNCOVERED BY THE FORCE OF FLOWING WATER, AND IT IS BURIED BY THE SAME CURRENTS.

IF YOU WANT TO LEARN ABOUT YOUR OWN TREASURE, YOU WILL HAVE TO GIVE ME ONE-TENTH OF YOUR FLOCK.

WHAT ABOUT ONE-TENTH OF MY TREASURE?

IF YOU START OUT BY PROMISING WHAT YOU DON'T EVEN HAVE YET, YOU'LL LOSE YOUR DESIRE TO WORK TOWARD GETTING IT.

I HAVE ALREADY PROMISED THE GYPSY ONE-TENTH OF THE TREASURE.

:SIGH:

GYPSIES ARE EXPERTS AT GETTING PEOPLE TO DO THAT.

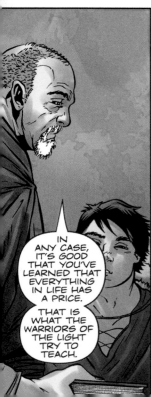

IN ANY CASE, IT'S GOOD THAT YOU'VE LEARNED THAT EVERYTHING IN LIFE HAS A PRICE.

THAT IS WHAT THE WARRIORS OF THE LIGHT TRY TO TEACH.

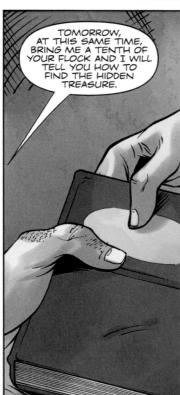

TOMORROW, AT THIS SAME TIME, BRING ME A TENTH OF YOUR FLOCK AND I WILL TELL YOU HOW TO FIND THE HIDDEN TREASURE.

GOOD AFTERNOON.

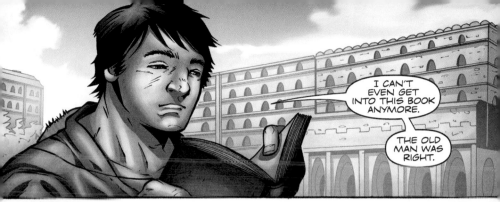

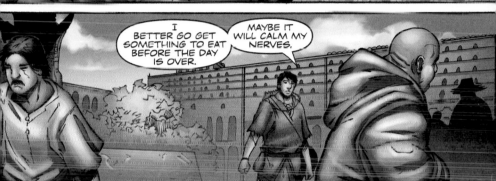

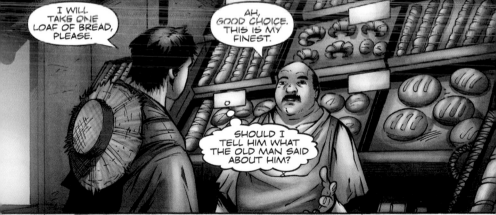

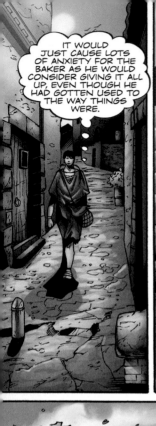

IT WOULD JUST CAUSE LOTS OF ANXIETY FOR THE BAKER AS HE WOULD CONSIDER GIVING IT ALL UP, EVEN THOUGH HE HAD GOTTEN USED TO THE WAY THINGS WERE.

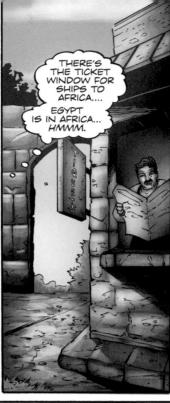

THERE'S THE TICKET WINDOW FOR SHIPS TO AFRICA....

EGYPT IS IN AFRICA... HMMM.

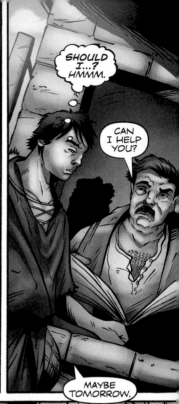

SHOULD I...? HMMM.

CAN I HELP YOU?

MAYBE TOMORROW.

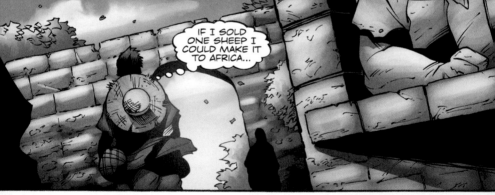

IF I SOLD ONE SHEEP I COULD MAKE IT TO AFRICA...

WHO WAS THAT?

ANOTHER DREAMER.

HE DOESN'T HAVE ENOUGH MONEY TO TRAVEL.

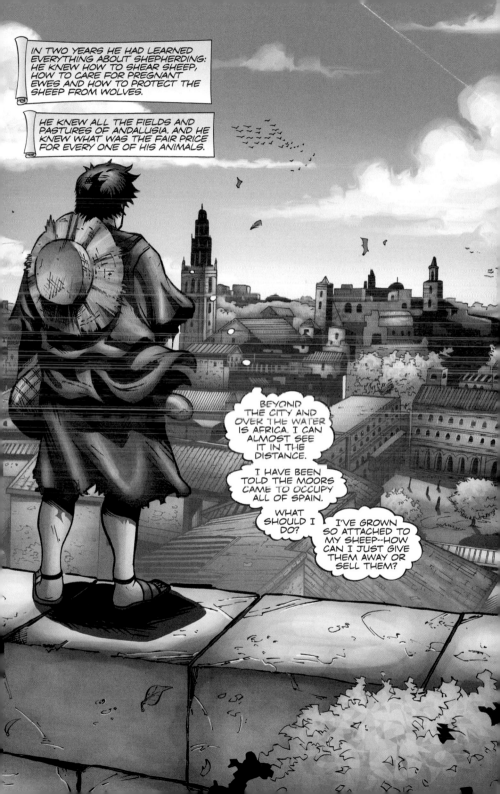

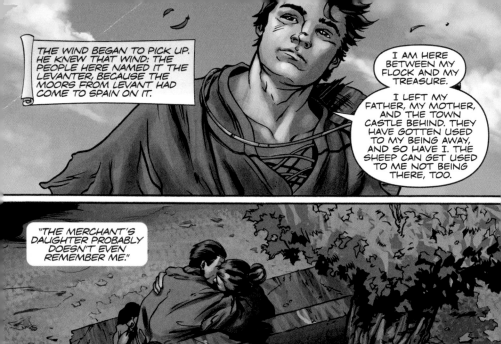

THE WIND BEGAN TO PICK UP. HE KNEW THAT WIND: THE PEOPLE HERE NAMED IT THE LEVANTER, BECAUSE THE MOORS FROM LEVANT HAD COME TO SPAIN ON IT.

I AM HERE BETWEEN MY FLOCK AND MY TREASURE.

I LEFT MY FATHER, MY MOTHER, AND THE TOWN CASTLE BEHIND. THEY HAVE GOTTEN USED TO MY BEING AWAY, AND SO HAVE I. THE SHEEP CAN GET USED TO ME NOT BEING THERE, TOO.

"THE MERCHANT'S DAUGHTER PROBABLY DOESN'T EVEN REMEMBER ME."

THAT BAKER...

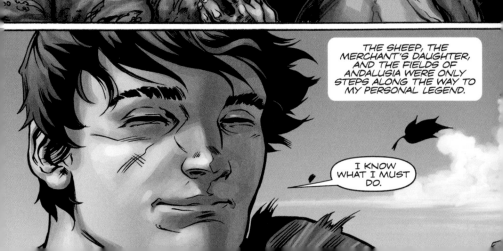

THE SHEEP, THE MERCHANT'S DAUGHTER, AND THE FIELDS OF ANDALUSIA WERE ONLY STEPS ALONG THE WAY TO MY PERSONAL LEGEND.

I KNOW WHAT I MUST DO.

The next day

I'M SURPRISED.

MY FRIEND BOUGHT ALL THE OTHER SHEEP IMMEDIATELY.

HE SAID THAT HE HAD ALWAYS DREAMED OF BEING A SHEPHERD, AND THAT IT WAS A GOOD OMEN.

THAT'S THE WAY IT ALWAYS IS. IT'S CALLED THE PRINCIPLE OF FAVORABILITY.

WHEN YOU PLAY CARDS THE FIRST TIME, YOU ARE ALMOST ALWAYS SURE TO WIN. BEGINNER'S LUCK.

WHY IS THAT?

BECAUSE THERE IS A FORCE THAT WANTS YOU TO REALIZE YOUR PERSONAL LEGEND; IT WHETS YOUR APPETITE WITH A TASTE OF SUCCESS.

THESE ARE VERY GOOD SHEEP.

WHAT ABOUT THIS LAME SHEEP?

HER LAMENESS ISN'T IMPORTANT; THIS SHEEP IS THE MOST INTELLIGENT AND PRODUCES THE MOST WOOL.

SHE IS WORTH TWICE AS MUCH AS THE OTHER ONES.

THEN, I WILL ACCEPT ALL THESE SHEEP.

WHERE IS THE TREASURE?

IT'S IN EGYPT, NEAR THE PYRAMID.

IN ORDER TO FIND THE TREASURE, YOU WILL HAVE TO FOLLOW THE OMENS. GOD HAS PREPARED A PATH FOR EVERYONE TO FOLLOW.

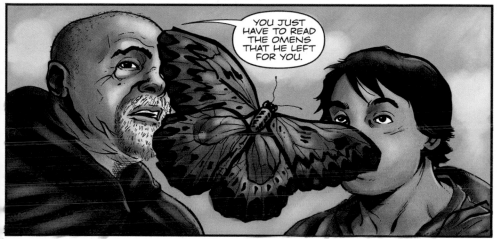

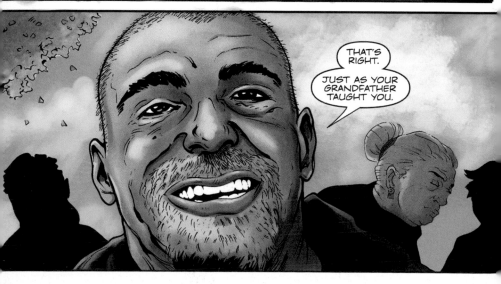

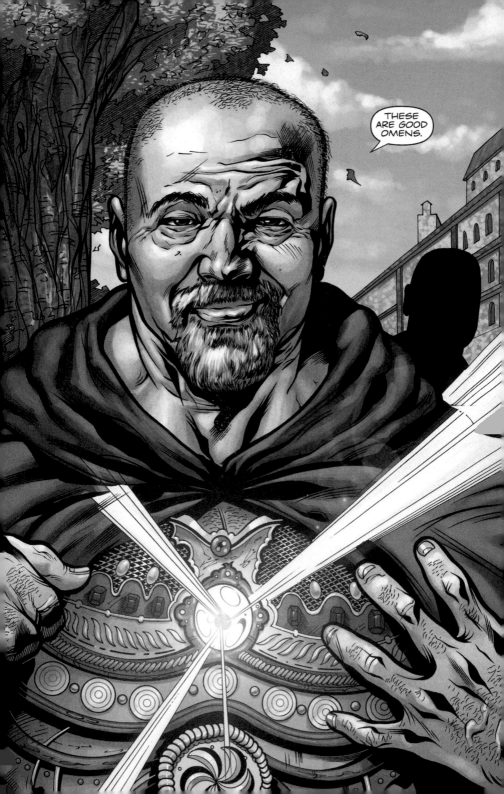

TAKE
THESE.

THEY
ARE CALLED
URIM AND
THUMMIM.

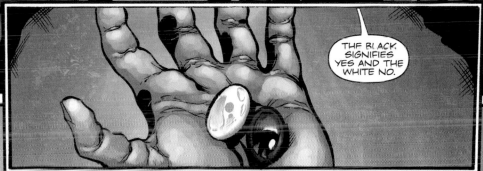
THE BLACK
SIGNIFIES
YES AND THE
WHITE NO.

WHEN
YOU ARE UNABLE
TO READ THE
OMENS, THEY
WILL HELP YOU
DO SO.

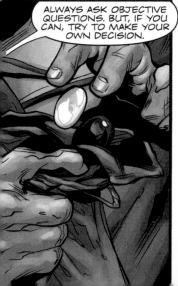
ALWAYS ASK OBJECTIVE
QUESTIONS. BUT, IF YOU
CAN, TRY TO MAKE YOUR
OWN DECISION.

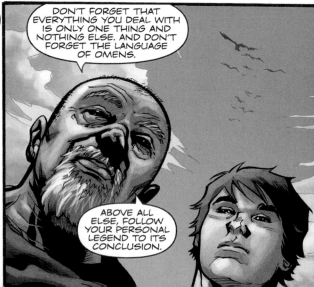
DON'T FORGET THAT
EVERYTHING YOU DEAL WITH
IS ONLY ONE THING AND
NOTHING ELSE. AND DON'T
FORGET THE LANGUAGE
OF OMENS.

ABOVE ALL
ELSE, FOLLOW
YOUR PERSONAL
LEGEND TO ITS
CONCLUSION.

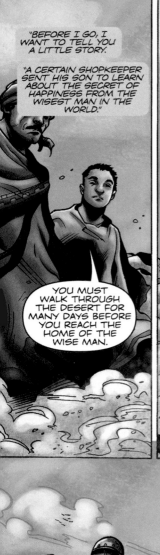
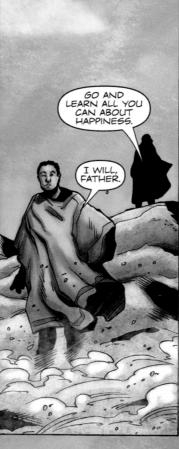

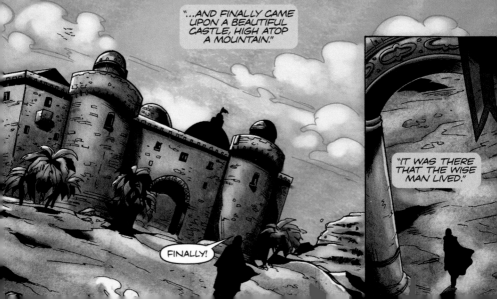

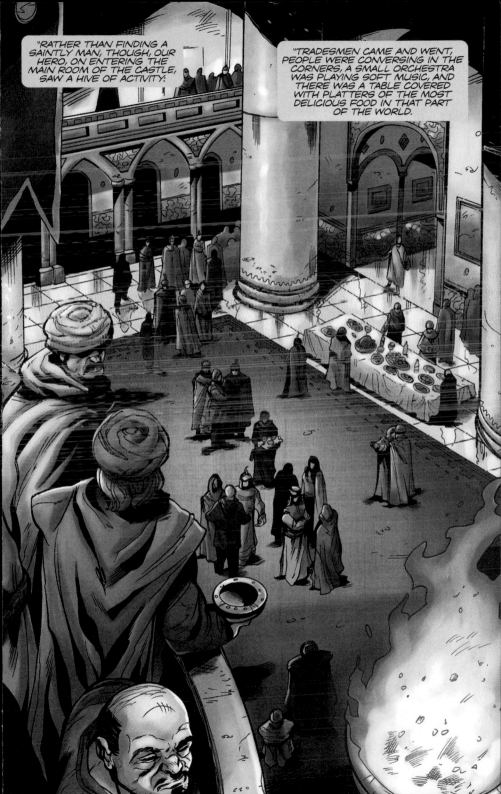

"RATHER THAN FINDING A SAINTLY MAN, THOUGH, OUR HERO, ON ENTERING THE MAIN ROOM OF THE CASTLE, SAW A HIVE OF ACTIVITY:

"TRADESMEN CAME AND WENT, PEOPLE WERE CONVERSING IN THE CORNERS, A SMALL ORCHESTRA WAS PLAYING SOFT MUSIC, AND THERE WAS A TABLE COVERED WITH PLATTERS OF THE MOST DELICIOUS FOOD IN THAT PART OF THE WORLD.

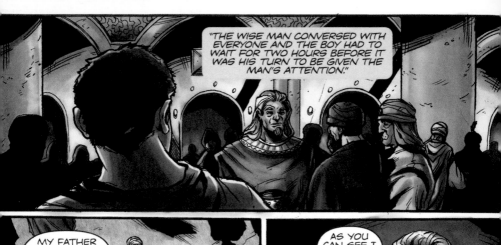

"THE WISE MAN CONVERSED WITH EVERYONE AND THE BOY HAD TO WAIT FOR TWO HOURS BEFORE IT WAS HIS TURN TO BE GIVEN THE MAN'S ATTENTION."

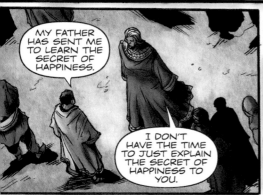

MY FATHER HAS SENT ME TO LEARN THE SECRET OF HAPPINESS.

I DON'T HAVE THE TIME TO JUST EXPLAIN THE SECRET OF HAPPINESS TO YOU.

AS YOU CAN SEE I AM A VERY BUSY MAN.

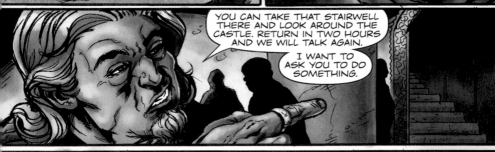

YOU CAN TAKE THAT STAIRWELL THERE AND LOOK AROUND THE CASTLE. RETURN IN TWO HOURS AND WE WILL TALK AGAIN.

I WANT TO ASK YOU TO DO SOMETHING.

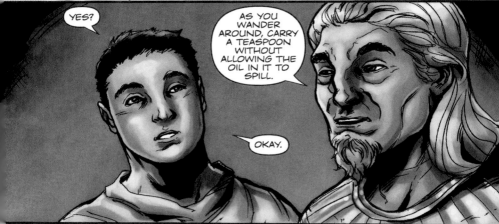

YES?

AS YOU WANDER AROUND, CARRY A TEASPOON WITHOUT ALLOWING THE OIL IN IT TO SPILL.

OKAY.

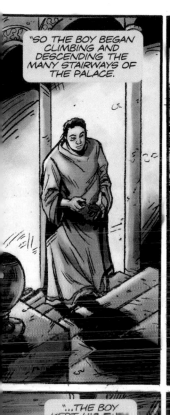

"SO THE BOY BEGAN CLIMBING AND DESCENDING THE MANY STAIRWAYS OF THE PALACE.

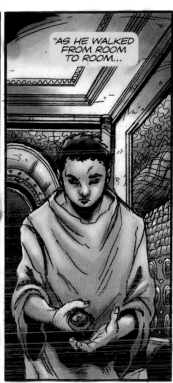

"AS HE WALKED FROM ROOM TO ROOM...

"...AND PLACE TO PLACE...

"...THE BOY KEPT HIS EYES ON THE SPOON AND THE OIL.

"AFTER TWO HOURS, HE RETURNED TO THE ROOM WHERE THE WISE MAN WAS."

WELL!
DID YOU SEE THE PERSIAN TAPESTRIES THAT ARE HANGING IN MY DYING HALL?

DID YOU SEE THE GARDEN THAT IT TOOK THE MASTER GARDENER TEN YEARS TO CREATE?

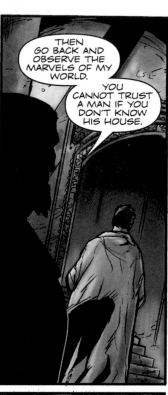

DID YOU NOTICE THE BEAUTIFUL PARCHMENTS IN MY LIBRARY?

I DID NOT.

MY ONLY CONCERN WAS TO NOT SPILL THE OIL.

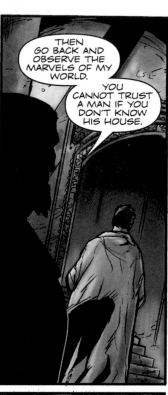

THEN GO BACK AND OBSERVE THE MARVELS OF MY WORLD.

YOU CANNOT TRUST A MAN IF YOU DON'T KNOW HIS HOUSE.

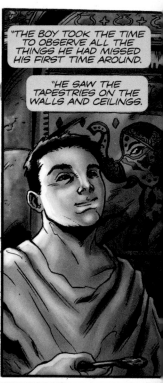

"THE BOY TOOK THE TIME TO OBSERVE ALL THE THINGS HE HAD MISSED HIS FIRST TIME AROUND.

"HE SAW THE TAPESTRIES ON THE WALLS AND CEILINGS.

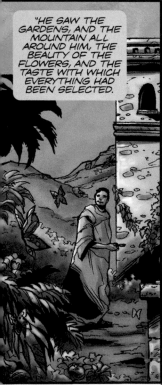

"HE SAW THE GARDENS, AND THE MOUNTAIN ALL AROUND HIM, THE BEAUTY OF THE FLOWERS, AND THE TASTE WITH WHICH EVERYTHING HAD BEEN SELECTED.

"HE SAW THE BOOKS AND SCROLLS IN THE GREAT LIBRARY.

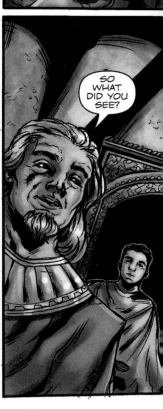

SO WHAT DID YOU SEE?

I SAW ALL THE GREAT WONDERS OF THE PALACE.

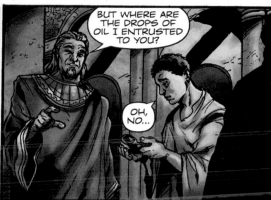

BUT WHERE ARE THE DROPS OF OIL I ENTRUSTED TO YOU?

OH, NO...

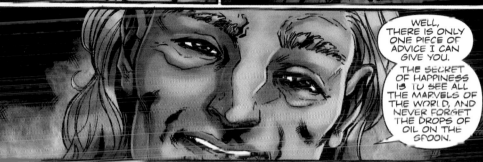

WELL, THERE IS ONLY ONE PIECE OF ADVICE I CAN GIVE YOU.

THE SECRET OF HAPPINESS IS TO SEE ALL THE MARVELS OF THE WORLD, AND NEVER FORGET THE DROPS OF OIL ON THE SPOON.

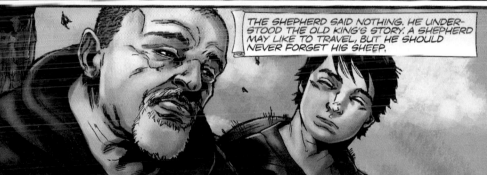

THE SHEPHERD SAID NOTHING. HE UNDERSTOOD THE OLD KING'S STORY. A SHEPHERD MAY LIKE TO TRAVEL, BUT HE SHOULD NEVER FORGET HIS SHEEP.

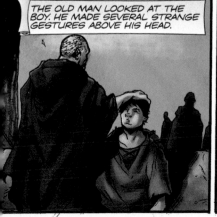

THE OLD MAN LOOKED AT THE BOY. HE MADE SEVERAL STRANGE GESTURES ABOVE HIS HEAD.

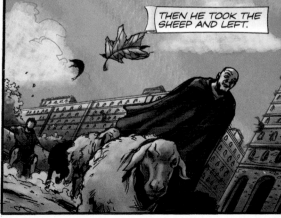

THEN HE TOOK THE SHEEP AND LEFT.

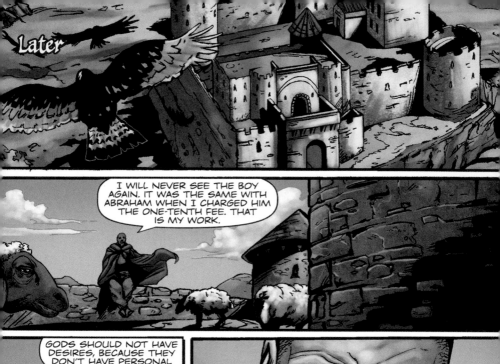

Later

I WILL NEVER SEE THE BOY AGAIN. IT WAS THE SAME WITH ABRAHAM WHEN I CHARGED HIM THE ONE-TENTH FEE. THAT IS MY WORK.

GODS SHOULD NOT HAVE DESIRES, BECAUSE THEY DON'T HAVE PERSONAL LEGENDS.

BUT I HOPE DESPERATELY THE BOY WILL BE SUCCESSFUL.

IT'S TOO BAD HE IS GOING TO FORGET MY NAME. I SHOULD HAVE REPEATED IT FOR HIM.

THEN WHEN HE SPOKE ABOUT ME, HE WOULD SAY THAT I AM MELCHIZEDEK, THE KING OF SALEM.

I KNOW IT'S THE VANITY OF VANITIES, AS YOU SAID, MY LORD. BUT AN OLD KING SOMETIMES HAS TO TAKE SOME PRIDE IN HIMSELF.

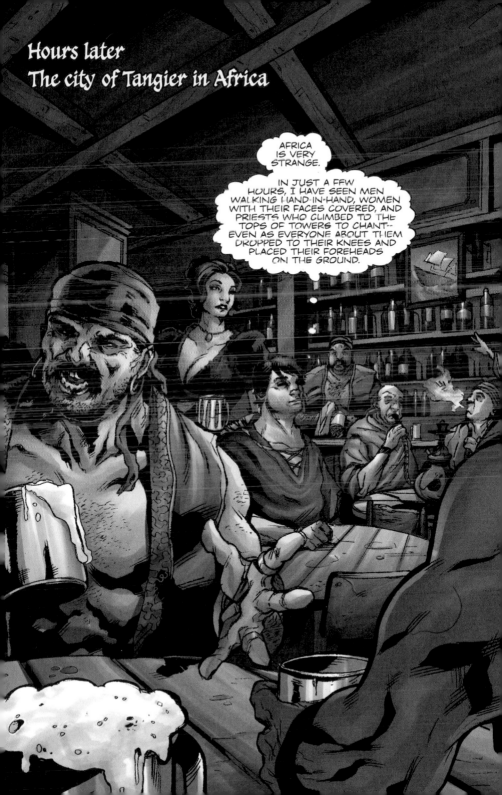

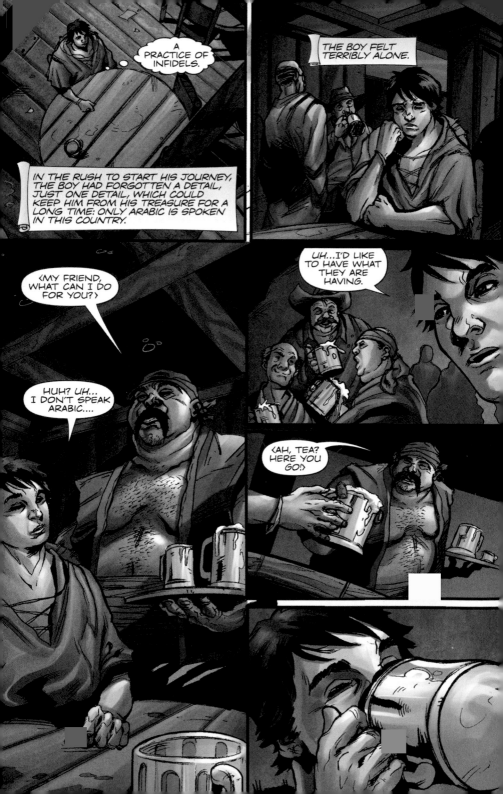

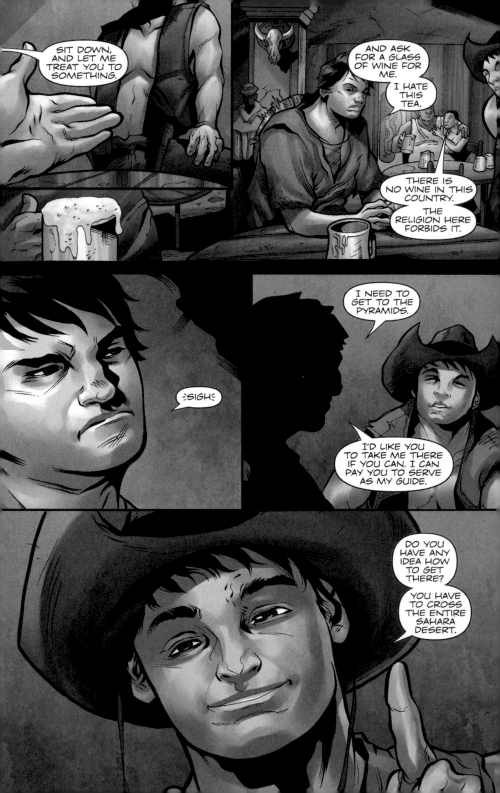

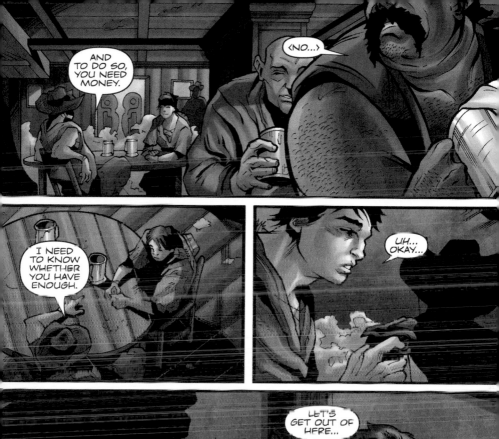

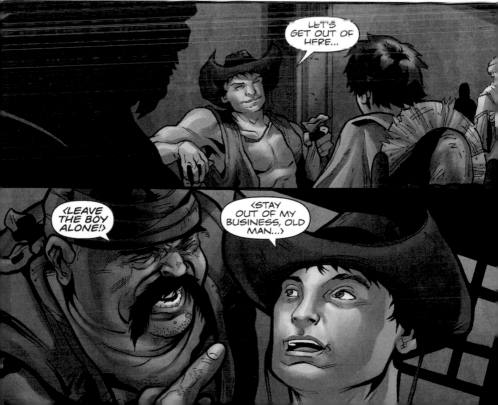

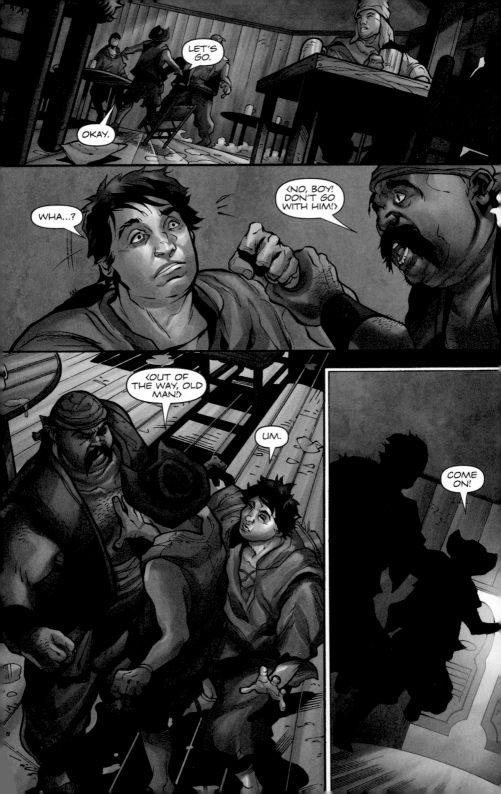

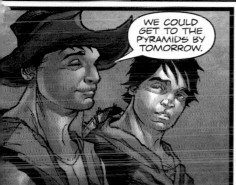

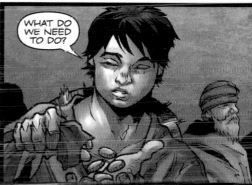

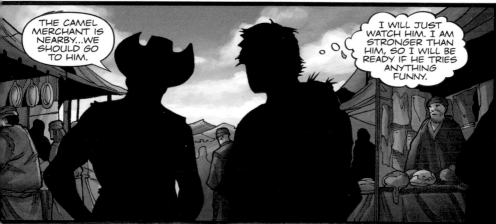

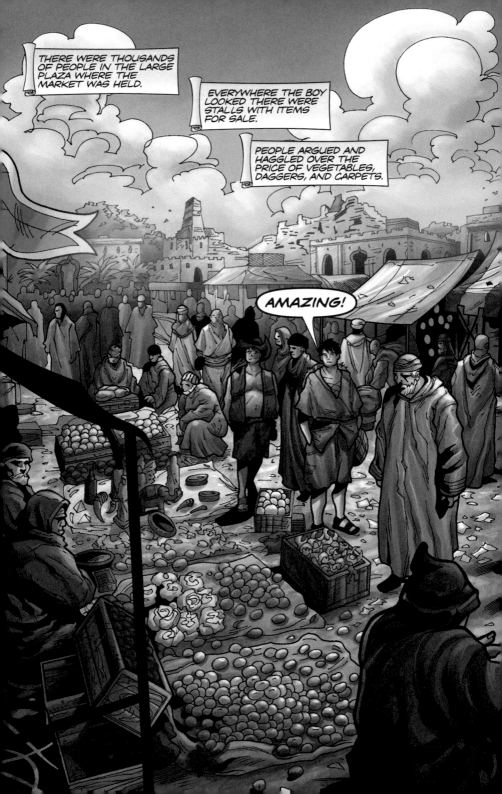

THIS IS AMAZING, MY FRIEND.

SWORDS, DAGGERS, AND ARMOR!

"WHEN I RETURN FROM EGYPT WITH MY TREASURE, I WILL BUY THAT SWORD."

ASK THE OWNER OF THAT STALL HOW MUCH THE SWORD COSTS.

OH, NO!

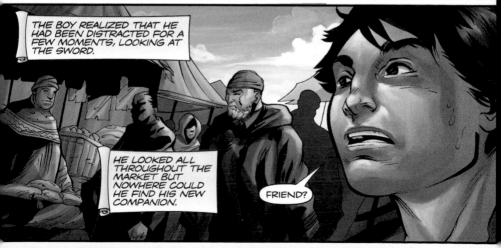

THE BOY REALIZED THAT HE HAD BEEN DISTRACTED FOR A FEW MOMENTS, LOOKING AT THE SWORD.

HE LOOKED ALL THROUGHOUT THE MARKET BUT NOWHERE COULD HE FIND HIS NEW COMPANION.

FRIEND?

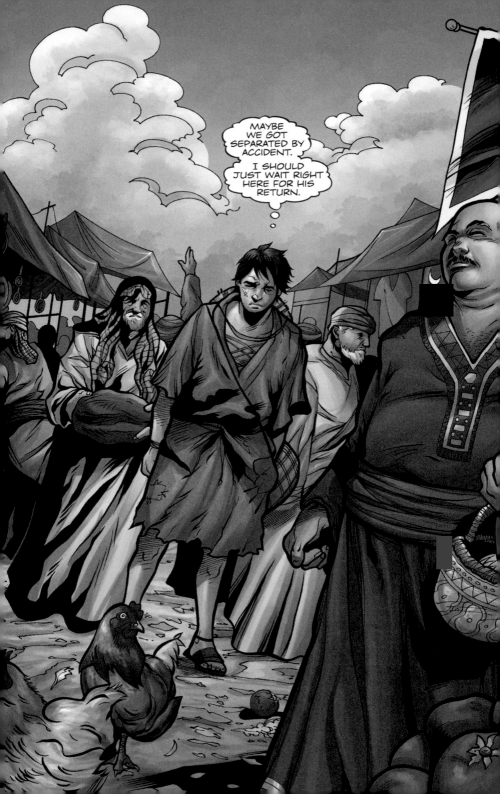

MAYBE HE IS LOST.

ALLAHU AKBAR.

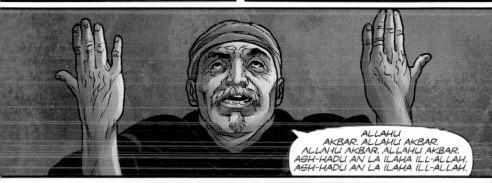

ALLAHU AKBAR. ALLAHU AKBAR. ALLAHU AKBAR. ALLAHU AKBAR. ASH-HADU AN LA ILAHA ILL-ALLAH. ASH-HADU AN LA ILAHA ILL-ALLAH.

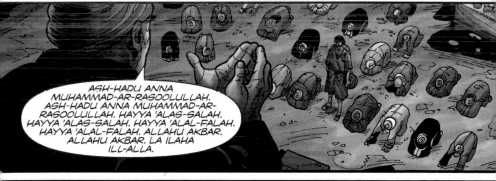

ASH-HADU ANNA MUHAMMAD-AR-RASOOLULLAH. ASH-HADU ANNA MUHAMMAD-AR-RASOOLULLAH. HAYYA 'ALAS-SALAH. HAYYA 'ALAS-SALAH. HAYYA 'ALAL-FALAH. HAYYA 'ALAL-FALAH. ALLAHU AKBAR. ALLAHU AKBAR. LA ILAHA ILL-ALLA.

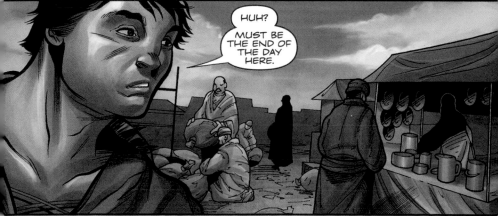

HUH? MUST BE THE END OF THE DAY HERE.

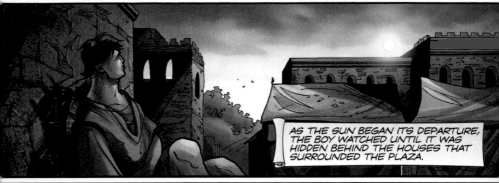

AS THE SUN BEGAN ITS DEPARTURE, THE BOY WATCHED UNTIL IT WAS HIDDEN BEHIND THE HOUSES THAT SURROUNDED THE PLAZA.

WHEN THE SUN ROSE THIS MORNING, I HAD SO MUCH.

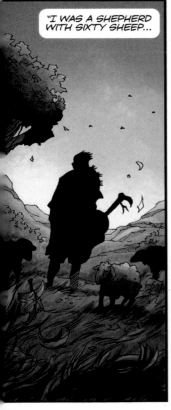

"I WAS A SHEPHERD WITH SIXTY SHEEP...

"I WAS LOOKING FORWARD TO MEETING A GIRL.

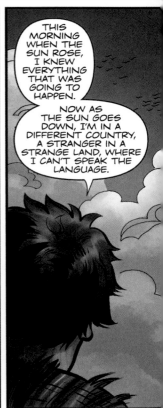

THIS MORNING WHEN THE SUN ROSE, I KNEW EVERYTHING THAT WAS GOING TO HAPPEN.

NOW AS THE SUN GOES DOWN, I'M IN A DIFFERENT COUNTRY, A STRANGER IN A STRANGE LAND, WHERE I CAN'T SPEAK THE LANGUAGE.

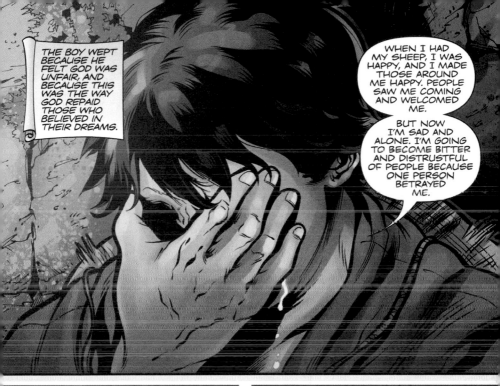

THE BOY WEPT BECAUSE HE FELT GOD WAS UNFAIR, AND BECAUSE THIS WAS THE WAY GOD REPAID THOSE WHO BELIEVED IN THEIR DREAMS.

WHEN I HAD MY SHEEP, I WAS HAPPY, AND I MADE THOSE AROUND ME HAPPY. PEOPLE SAW ME COMING AND WELCOMED ME.

BUT NOW I'M SAD AND ALONE. I'M GOING TO BECOME BITTER AND DISTRUSTFUL OF PEOPLE BECAUSE ONE PERSON BETRAYED ME.

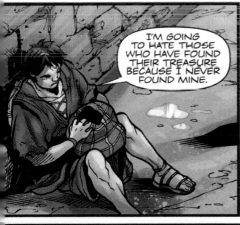

I'M GOING TO HATE THOSE WHO HAVE FOUND THEIR TREASURE BECAUSE I NEVER FOUND MINE.

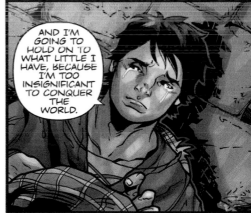

AND I'M GOING TO HOLD ON TO WHAT LITTLE I HAVE, BECAUSE I'M TOO INSIGNIFICANT TO CONQUER THE WORLD.

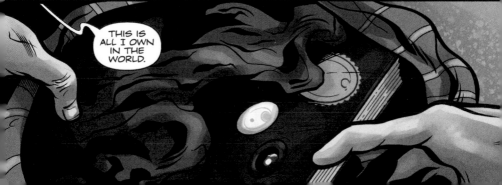

THIS IS ALL I OWN IN THE WORLD.

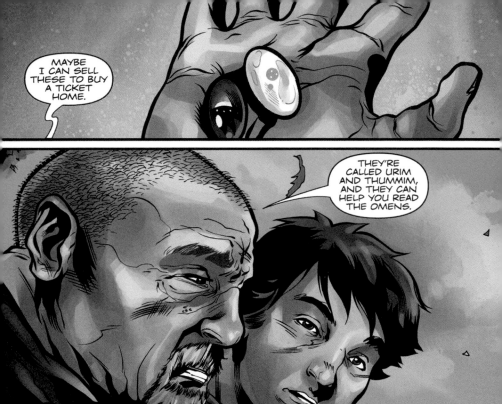

MAYBE I CAN SELL THESE TO BUY A TICKET HOME.

THEY'RE CALLED URIM AND THUMMIM, AND THEY CAN HELP YOU READ THE OMENS.

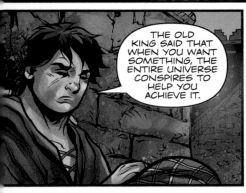

THE OLD KING SAID THAT WHEN YOU WANT SOMETHING, THE ENTIRE UNIVERSE CONSPIRES TO HELP YOU ACHIEVE IT.

LET ME SEE IF THESE WORK. IS THE OLD MAN'S BLESSING STILL UPON ME?

IT SAYS YES.

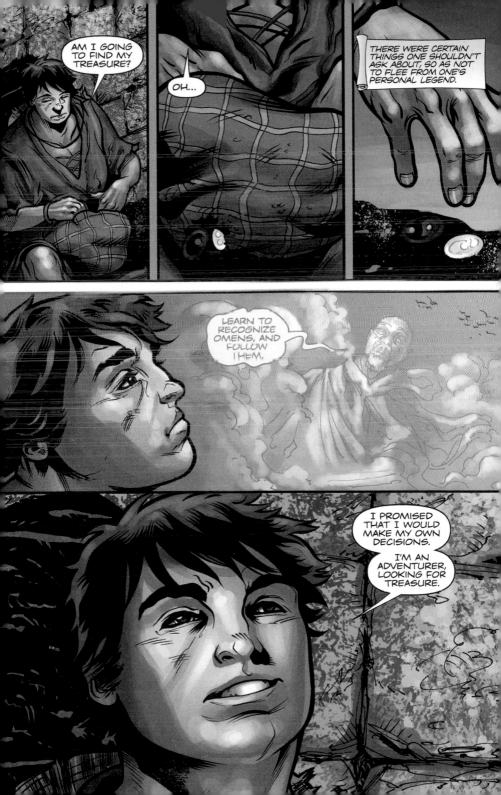

ASALAAM ALAIKUM.

HELLO.

THIS CANDY MERCHANT ISN'T MAKING CANDY SO THAT LATER HE CAN TRAVEL OR MARRY A SHOPKEEPER'S DAUGHTER. HE'S DOING IT CAUSE IT'S WHAT HE WANTS TO DO.

LIKE THE OLD MAN, I CAN SENSE WHEN A PERSON IS NEAR OR FAR FROM HIS PERSONAL LEGEND.

IT'S VERY EASY, YET I'VE NEVER DONE IT BEFORE.

YUM!

GOODBYE, MY FRIEND!

THERE MUST BE A LANGUAGE THAT DOESN'T DEPEND ON WORDS.

EVEN THOUGH I SPOKE SPANISH AND THE CANDY MERCHANT SPOKE ARABIC, WE UNDERSTOOD EACH OTHER PERFECTLY.

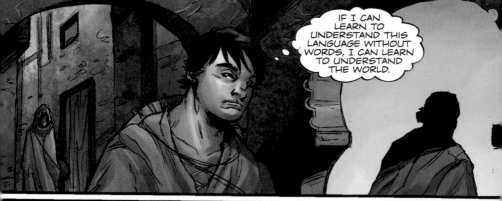

IF I CAN LEARN TO UNDERSTAND THIS LANGUAGE WITHOUT WORDS, I CAN LEARN TO UNDERSTAND THE WORLD.

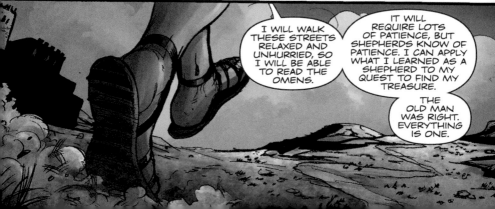

I WILL WALK THESE STREETS RELAXED AND UNHURRIED, SO I WILL BE ABLE TO READ THE OMENS.

IT WILL REQUIRE LOTS OF PATIENCE, BUT SHEPHERDS KNOW OF PATIENCE. I CAN APPLY WHAT I LEARNED AS A SHEPHERD TO MY QUEST TO FIND MY TREASURE.

THE OLD MAN WAS RIGHT. EVERYTHING IS ONE.

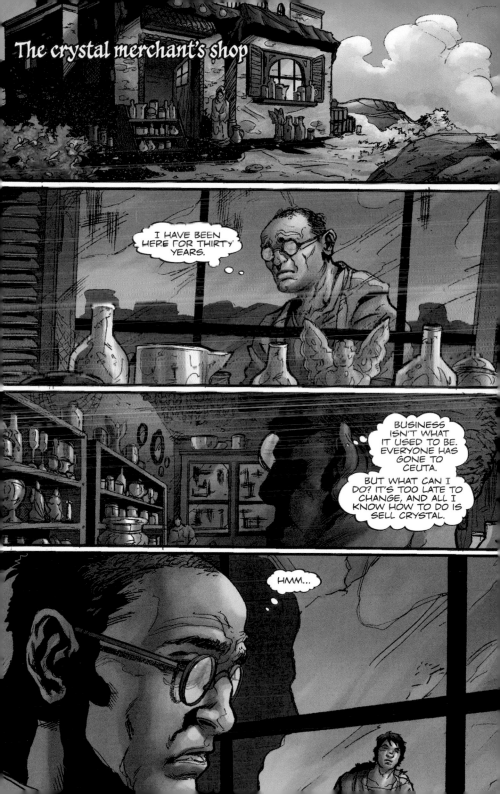

HELLO?

I CAN CLEAN THOSE GLASSES IN THE WINDOW, IF YOU WANT.

THE WAY THEY LOOK NOW, NOBODY IS GOING TO WANT TO BUY THEM.

HMMM...

IN EXCHANGE, YOU CAN GIVE ME SOMETHING TO EAT.

I WON'T BE NEEDING MY JACKET FOR THE DESERT SO I CAN USE IT TO CLEAN THESE CRYSTALS.

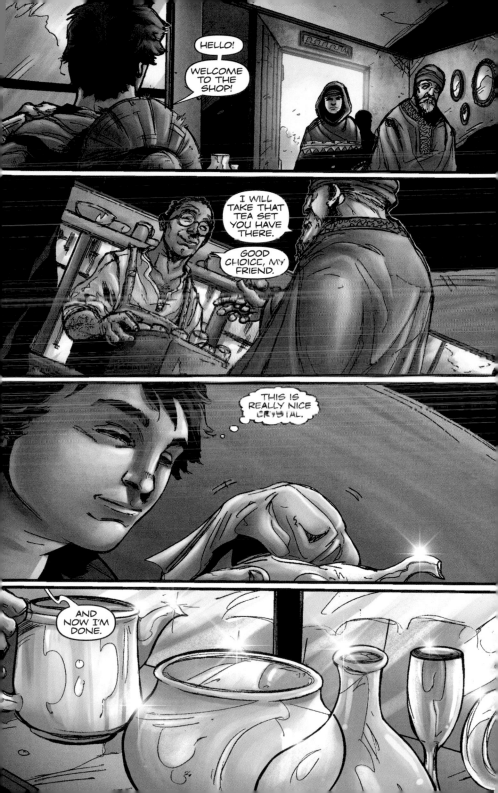

SO CAN I HAVE SOMETHING TO EAT?

LET'S GO AND HAVE SOME LUNCH.

YOU DIDN'T HAVE TO DO ANY CLEANING.

THE KORAN REQUIRES ME TO FEED A HUNGRY PERSON.

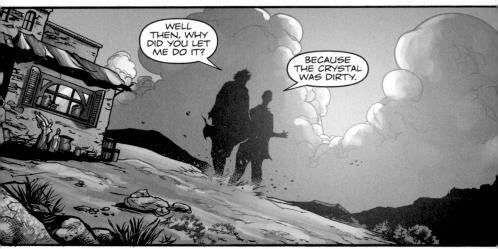

WELL THEN, WHY DID YOU LET ME DO IT?

BECAUSE THE CRYSTAL WAS DIRTY.

AND BOTH YOU AND I NEEDED TO CLEANSE OUR MINDS OF NEGATIVE THOUGHTS.

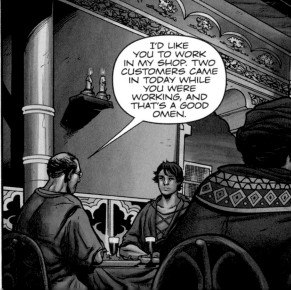

I'D LIKE YOU TO WORK IN MY SHOP. TWO CUSTOMERS CAME IN TODAY WHILE YOU WERE WORKING, AND THAT'S A GOOD OMEN.

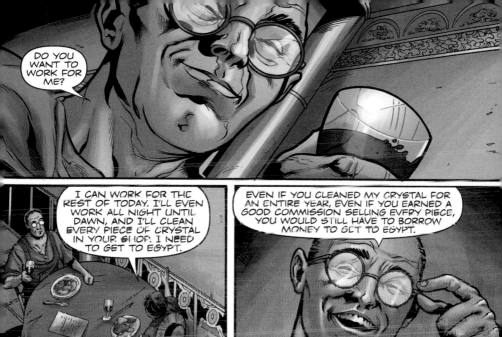

DO YOU WANT TO WORK FOR ME?

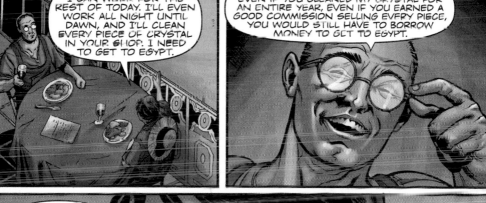

I CAN WORK FOR THE REST OF TODAY. I'LL EVEN WORK ALL NIGHT UNTIL DAWN, AND I'LL CLEAN EVERY PIECE OF CRYSTAL IN YOUR SHOP. I NEED TO GET TO EGYPT.

EVEN IF YOU CLEANED MY CRYSTAL FOR AN ENTIRE YEAR, EVEN IF YOU EARNED A GOOD COMMISSION SELLING EVERY PIECE, YOU WOULD STILL HAVE TO BORROW MONEY TO GET TO EGYPT.

THERE ARE THOUSANDS OF KILOMETERS OF DESERT BETWEEN HERE AND THERE.

:SIGH:

I NEED MONEY TO BUY SOME SHEEP.

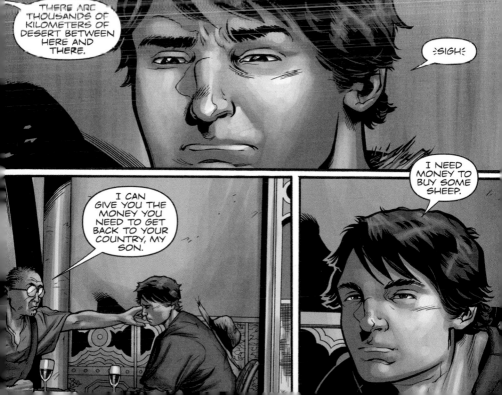

I CAN GIVE YOU THE MONEY YOU NEED TO GET BACK TO YOUR COUNTRY, MY SON.

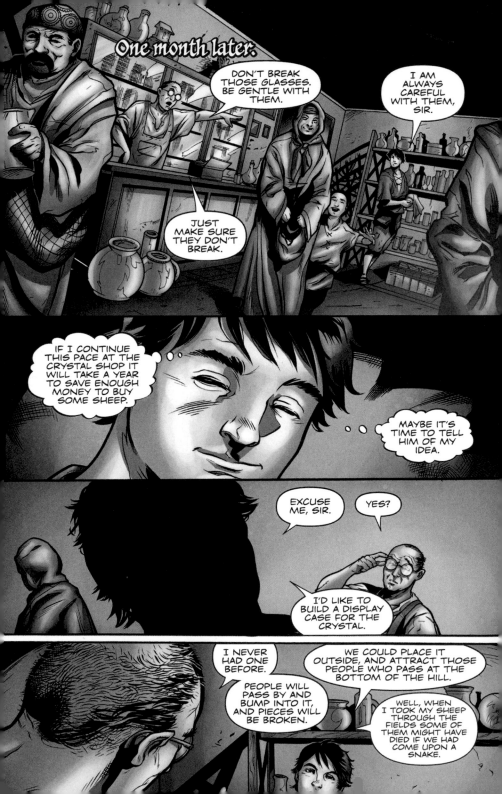

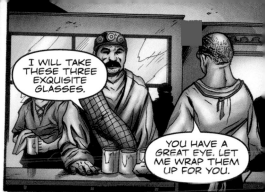

BUT THAT'S THE WAY LIFE IS WITH SHEEP AND WITH SHEPHERDS.

I WILL TAKE THESE THREE EXQUISITE GLASSES.

YOU HAVE A GREAT EYE. LET ME WRAP THEM UP FOR YOU.

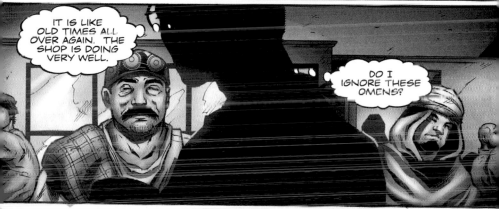

IT IS LIKE OLD TIMES ALL OVER AGAIN. THE SHOP IS DOING VERY WELL.

DO I IGNORE THESE OMENS?

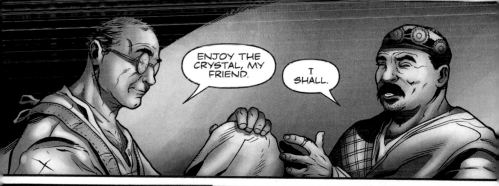

ENJOY THE CRYSTAL, MY FRIEND.

I SHALL.

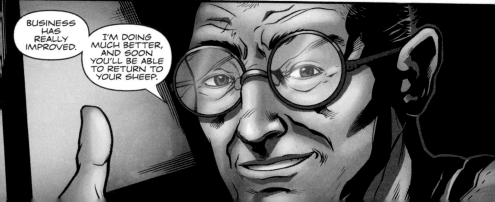

BUSINESS HAS REALLY IMPROVED.

I'M DOING MUCH BETTER, AND SOON YOU'LL BE ABLE TO RETURN TO YOUR SHEEP.

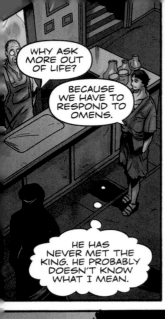

WHY ASK MORE OUT OF LIFE?

BECAUSE WE HAVE TO RESPOND TO OMENS.

HE HAS NEVER MET THE KING. HE PROBABLY DOESN'T KNOW WHAT I MEAN.

THE KING HAD CALLED IT THE PRINCIPLE OF FAVORABILITY, BEGINNER'S LUCK. LIFE WANTS YOU TO ACHIEVE YOUR PERSONAL LEGEND.

WHY DID YOU WANT TO GET TO THE PYRAMIDS?

BECAUSE I'VE ALWAYS HEARD ABOUT THEM.

I DON'T KNOW ANYONE AROUND HERE WHO WOULD WANT TO CROSS THE DESERT JUST TO SEE THE PYRAMIDS.

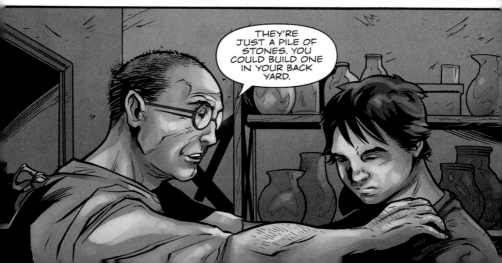

THEY'RE JUST A PILE OF STONES. YOU COULD BUILD ONE IN YOUR BACK YARD.

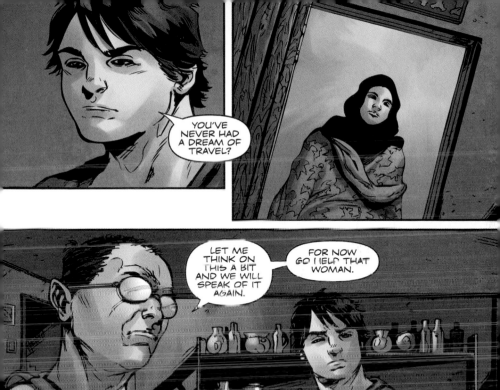

YOU'VE NEVER HAD A DREAM OF TRAVEL?

LET ME THINK ON THIS A BIT AND WE WILL SPEAK OF IT AGAIN.

FOR NOW GO HELP THAT WOMAN.

CAN I HELP YOU?

YES.

THE MERCHANT AND THE SHEPHERD WOULD NOT SPEAK AGAIN ON THE MATTER FOR TWO DAYS.

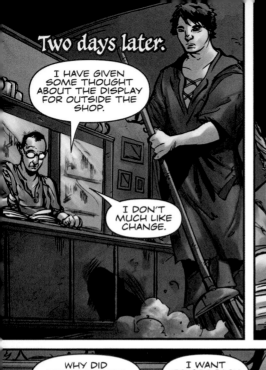

Two days later.

I HAVE GIVEN SOME THOUGHT ABOUT THE DISPLAY FOR OUTSIDE THE SHOP.

I DON'T MUCH LIKE CHANGE.

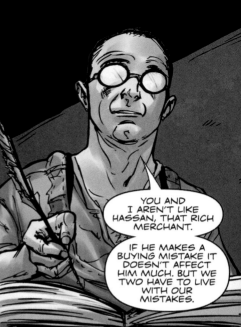

YOU AND I AREN'T LIKE HASSAN, THAT RICH MERCHANT.

IF HE MAKES A BUYING MISTAKE IT DOESN'T AFFECT HIM MUCH. BUT WE TWO HAVE TO LIVE WITH OUR MISTAKES.

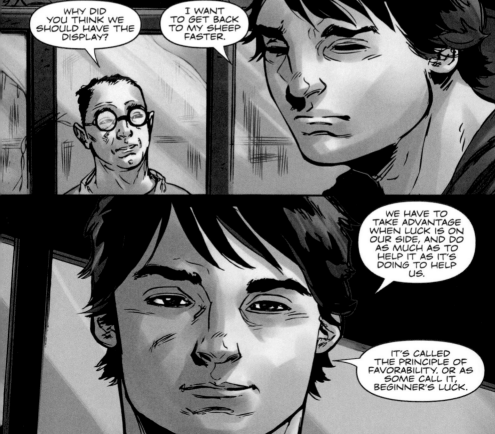

WHY DID YOU THINK WE SHOULD HAVE THE DISPLAY?

I WANT TO GET BACK TO MY SHEEP FASTER.

WE HAVE TO TAKE ADVANTAGE WHEN LUCK IS ON OUR SIDE, AND DO AS MUCH AS TO HELP IT AS IT'S DOING TO HELP US.

IT'S CALLED THE PRINCIPLE OF FAVORABILITY. OR AS SOME CALL IT, BEGINNER'S LUCK.

THE PROPHET GAVE US THE KORAN, AND LEFT US JUST FIVE OBLIGATIONS TO SATISFY DURING OUR LIVES.

THE MOST IMPORTANT IS BELIEVE IN THE ONLY ONE TRUE GOD.

THE OTHERS ARE TO PRAY FIVE TIMES A DAY, FAST DURING RAMADAN, AND BE CHARITABLE TO THE POOR...

HE WAS A DEVOUT MAN, AND, EVEN WITH ALL HIS IMPATIENCE, HE WANTED TO LIVE HIS LIFE ACCORDANCE WITH MUSLIM LAW.

WHAT'S THE FIFTH OBLIGATION?

TWO DAYS AGO, YOU SAID THAT I NEVER DREAMED OF TRAVEL.

THE FIFTH OBLIGATION OF EVERY MUSLIM IS A PILGRIMAGE.

WE ARE OBLIGED, AT LEAST ONCE IN OUR LIVES, TO VISIT THE HOLY CITY OF MECCA.

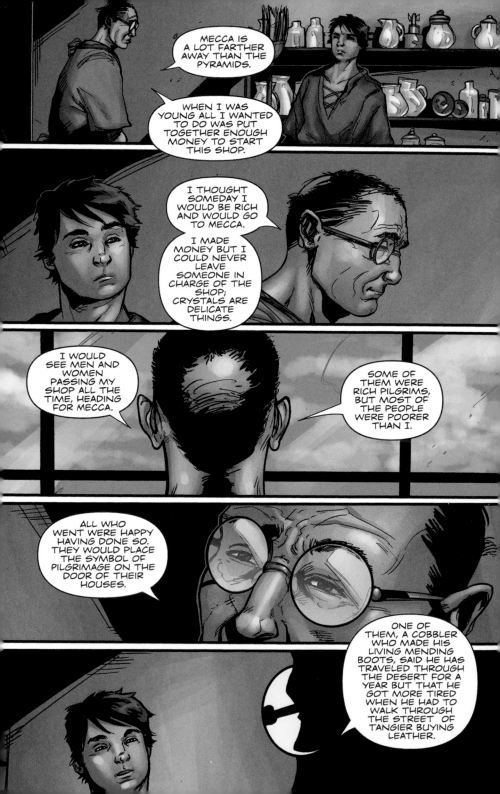

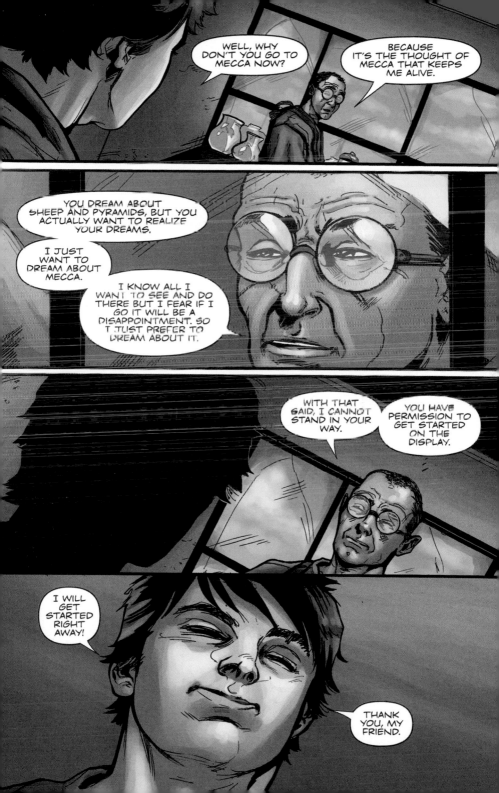

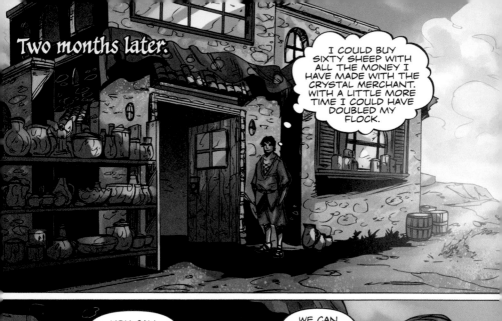

I COULD BUY SIXTY SHEEP WITH ALL THE MONEY I HAVE MADE WITH THE CRYSTAL MERCHANT. WITH A LITTLE MORE TIME I COULD HAVE DOUBLED MY FLOCK.

YOU CAN NEVER FIND A GOOD TEASHOP IN THIS PART OF THE CITY.

WE CAN JUST WAIT UNTIL WE HEAD DOWN THE HILL.

I GUESS WE HAVE TO.

OMENS ARE EVERYWHERE AS THE KING HAD SAID.

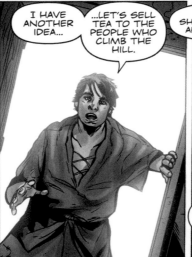

I HAVE ANOTHER IDEA...

...LET'S SELL TEA TO THE PEOPLE WHO CLIMB THE HILL.

LOTS OF SHOPS SELL TEA AROUND HERE.

WE COULD SELL IT IN CRYSTAL GLASSES. THE PEOPLE WILL ENJOY THE TEA AND WANT TO BUY THE GLASSES.

I HAVE BEEN TOLD BEAUTY IS A GREAT SEDUCER OF MEN.

I WILL THINK ON THIS.

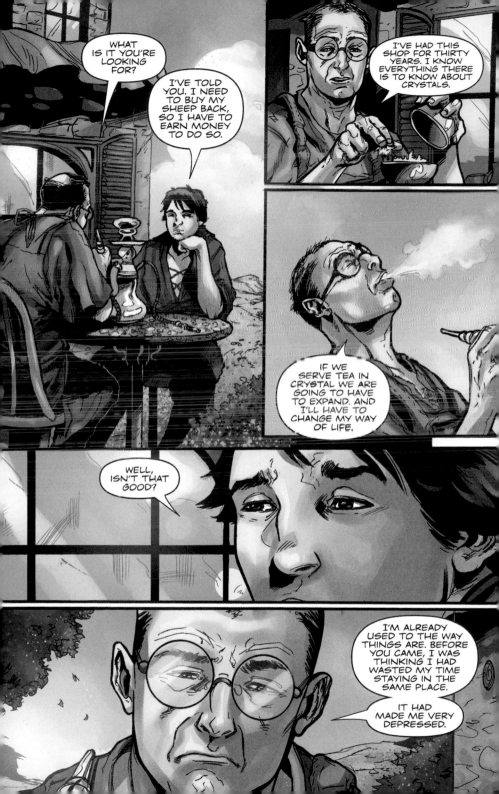

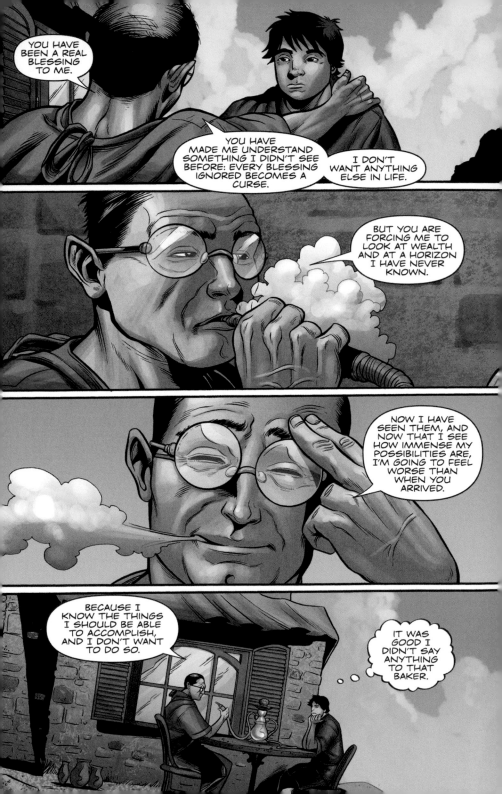

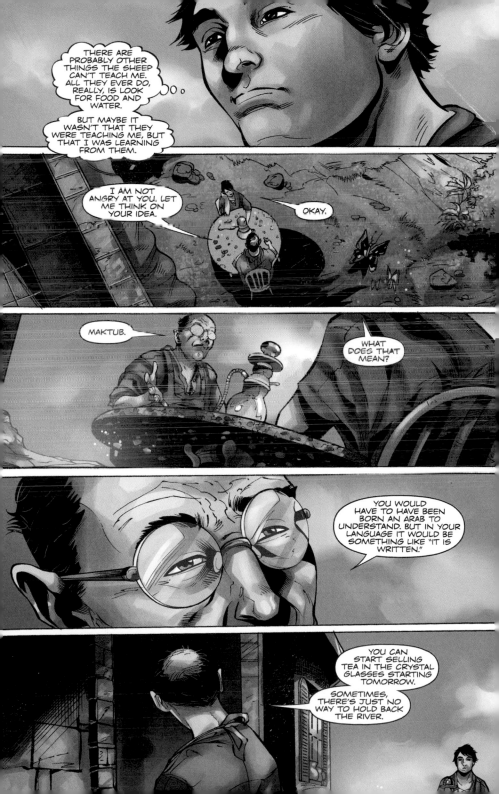

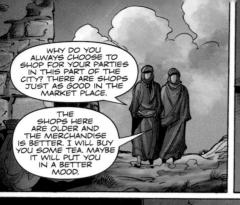

WHY DO YOU ALWAYS CHOOSE TO SHOP FOR YOUR PARTIES IN THIS PART OF THE CITY? THERE ARE SHOPS JUST AS GOOD IN THE MARKET PLACE.

THE SHOPS HERE ARE OLDER AND THE MERCHANDISE IS BETTER. I WILL BUY YOU SOME TEA. MAYBE IT WILL PUT YOU IN A BETTER MOOD.

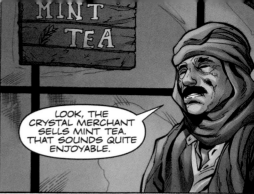

LOOK, THE CRYSTAL MERCHANT SELLS MINT TEA. THAT SOUNDS QUITE ENJOYABLE.

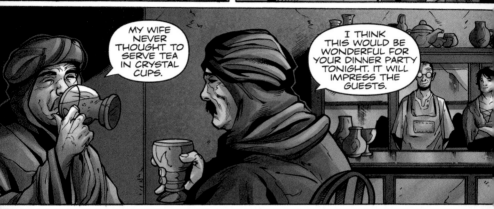

MY WIFE NEVER THOUGHT TO SERVE TEA IN CRYSTAL CUPS.

I THINK THIS WOULD BE WONDERFUL FOR YOUR DINNER PARTY TONIGHT. IT WILL IMPRESS THE GUESTS.

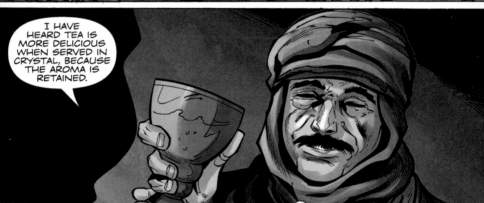

I HAVE HEARD TEA IS MORE DELICIOUS WHEN SERVED IN CRYSTAL, BECAUSE THE AROMA IS RETAINED.

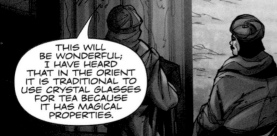

THIS WILL BE WONDERFUL; I HAVE HEARD THAT IN THE ORIENT IT IS TRADITIONAL TO USE CRYSTAL GLASSES FOR TEA BECAUSE IT HAS MAGICAL PROPERTIES.

BEFORE LONG, THE NEWS SPREAD, AND A GREAT MANY PEOPLE BEGAN TO CLIMB THE HILL TO SEE THE SHOP THAT WAS DOING NEW THINGS IN A TRADE THAT WAS SO OLD.

BUSINESS PICKED UP SO MUCH THE MERCHANT WOULD HAVE TO HIRE TWO MORE EMPLOYEES.

AND, IN THAT WAY, THE MONTHS PASSED.

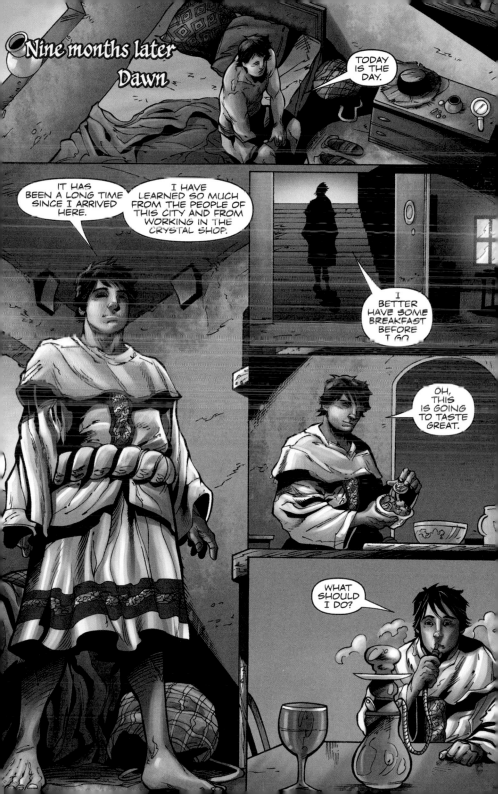

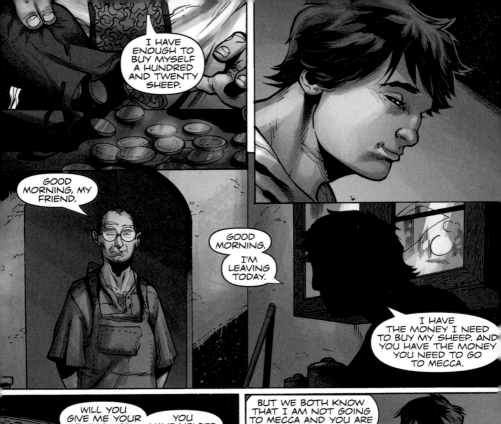

I HAVE ENOUGH TO BUY MYSELF A HUNDRED AND TWENTY SHEEP.

GOOD MORNING, MY FRIEND.

GOOD MORNING. I'M LEAVING TODAY.

I HAVE THE MONEY I NEED TO BUY MY SHEEP. AND YOU HAVE THE MONEY YOU NEED TO GO TO MECCA.

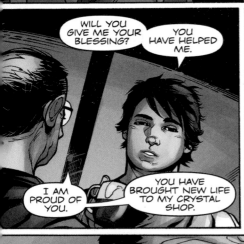

WILL YOU GIVE ME YOUR BLESSING?

YOU HAVE HELPED ME.

I AM PROUD OF YOU.

YOU HAVE BROUGHT NEW LIFE TO MY CRYSTAL SHOP.

BUT WE BOTH KNOW THAT I AM NOT GOING TO MECCA AND YOU ARE NOT GOING TO BUY YOUR SHEEP.

WHO TOLD YOU THAT?

MAKTUB.

GO WITH GOD.

I WONDER WHAT I SHOULD TAKE.

I WON'T NEED MY OLD SHEPHERD POUCH. MAYBE I CAN GIVE IT AWAY.

HMM?

URIM AND THUMMIM.

SEEING THE STONES MADE THE BOY THINK OF THE OLD KING AND WHAT HE HAD SAID.

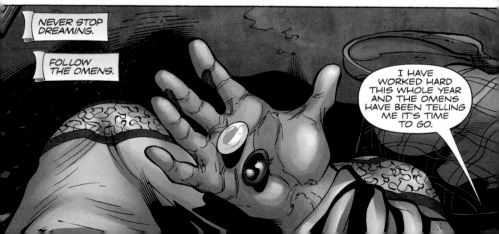

NEVER STOP DREAMING.

FOLLOW THE OMENS.

I HAVE WORKED HARD THIS WHOLE YEAR AND THE OMENS HAVE BEEN TELLING ME IT'S TIME TO GO.

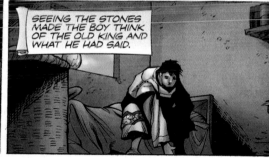

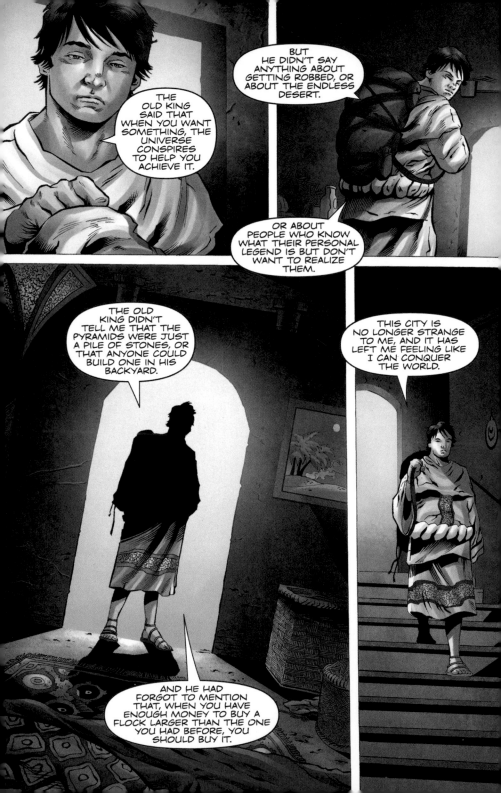

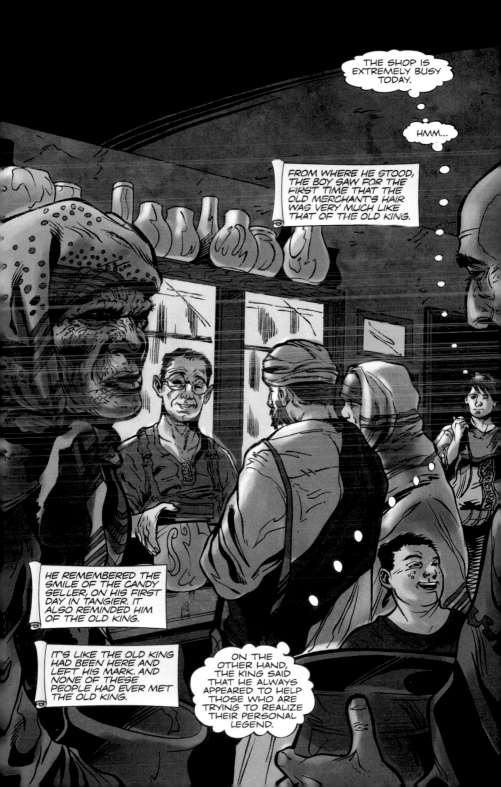

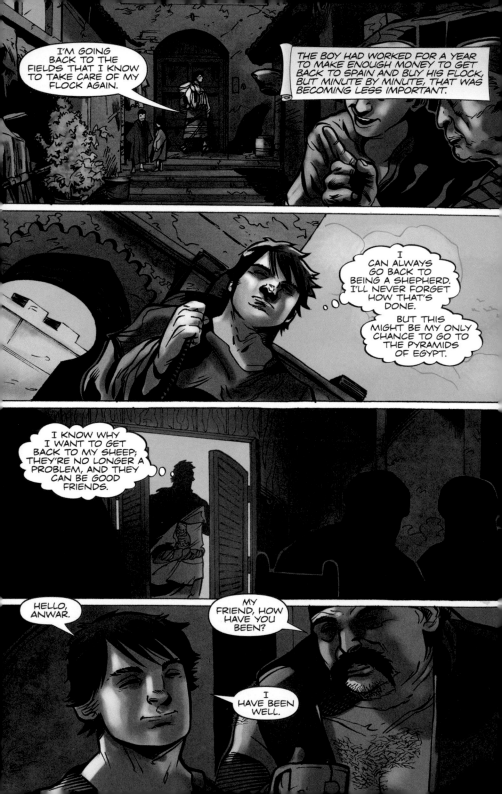

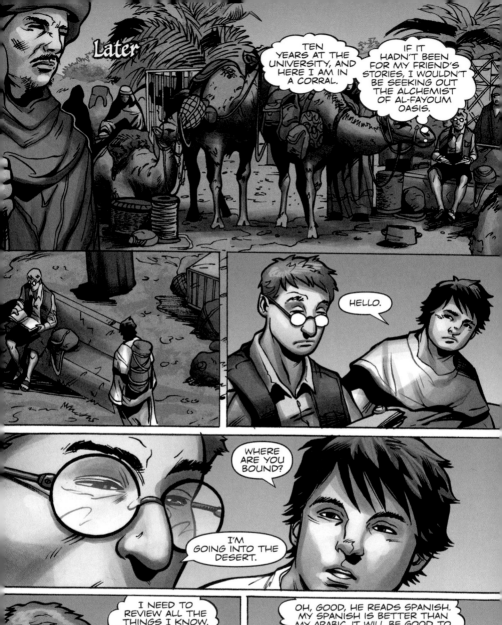

Later

TEN YEARS AT THE UNIVERSITY, AND HERE I AM IN A CORRAL.

IF IT HADN'T BEEN FOR MY FRIEND'S STORIES, I WOULDN'T BE SEEKING OUT THE ALCHEMIST OF AL-FAYOUM OASIS.

HELLO.

WHERE ARE YOU BOUND?

I'M GOING INTO THE DESERT.

I NEED TO REVIEW ALL THE THINGS I KNOW. THE ALCHEMIST IS SURE TO PUT ME THROUGH A TEST.

OH, GOOD, HE READS SPANISH. MY SPANISH IS BETTER THAN MY ARABIC. IT WILL BE GOOD TO HAVE SOMEONE TO TALK TO.

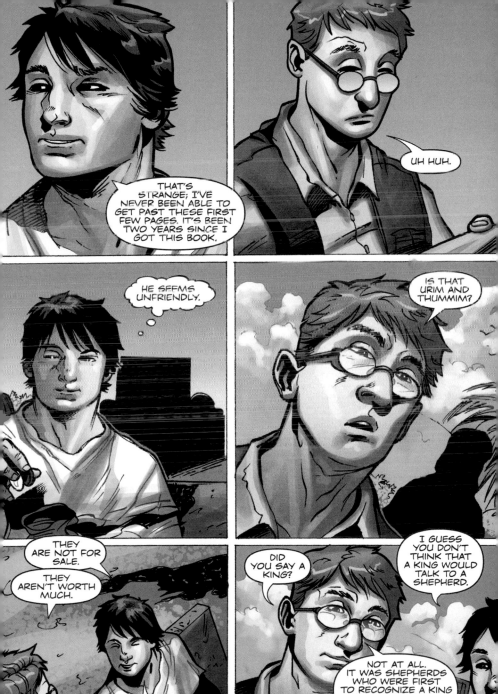

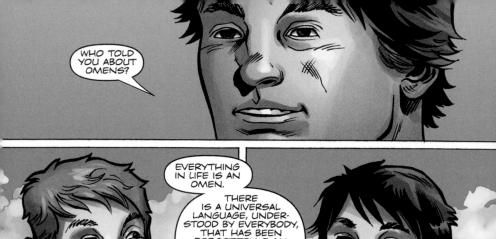

WHO TOLD YOU ABOUT OMENS?

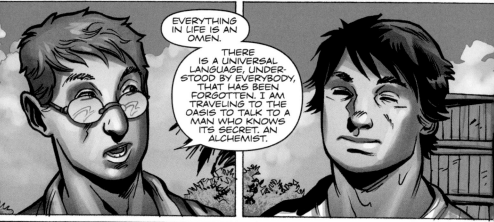

EVERYTHING IN LIFE IS AN OMEN.

THERE IS A UNIVERSAL LANGUAGE, UNDERSTOOD BY EVERYBODY, THAT HAS BEEN FORGOTTEN. I AM TRAVELING TO THE OASIS TO TALK TO A MAN WHO KNOWS ITS SECRET. AN ALCHEMIST.

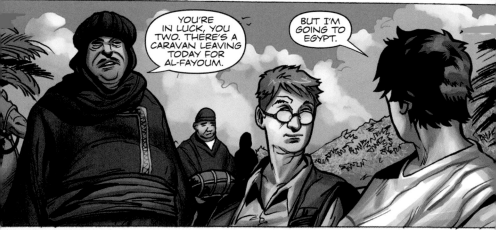

YOU'RE IN LUCK, YOU TWO. THERE'S A CARAVAN LEAVING TODAY FOR AL-FAYOUM.

BUT I'M GOING TO EGYPT.

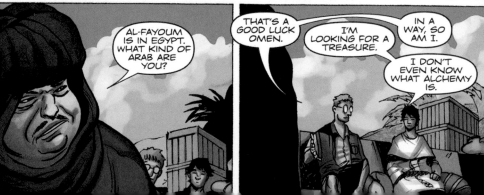

AL-FAYOUM IS IN EGYPT. WHAT KIND OF ARAB ARE YOU?

THAT'S A GOOD LUCK OMEN.

I'M LOOKING FOR A TREASURE.

IN A WAY, SO AM I.

I DON'T EVEN KNOW WHAT ALCHEMY IS.

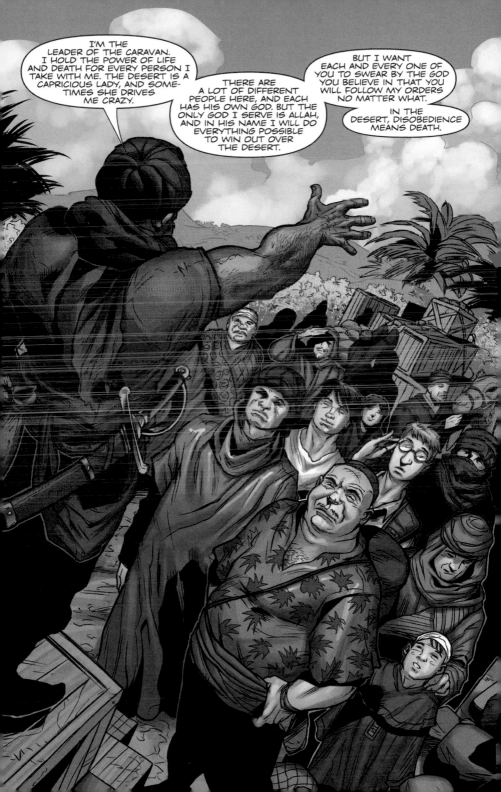

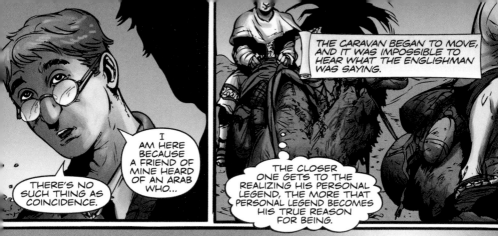

THERE'S NO SUCH THING AS COINCIDENCE.

I AM HERE BECAUSE A FRIEND OF MINE HEARD OF AN ARAB WHO...

THE CARAVAN BEGAN TO MOVE, AND IT WAS IMPOSSIBLE TO HEAR WHAT THE ENGLISHMAN WAS SAYING.

THE CLOSER ONE GETS TO THE REALIZING HIS PERSONAL LEGEND, THE MORE THAT PERSONAL LEGEND BECOMES HIS TRUE REASON FOR BEING.

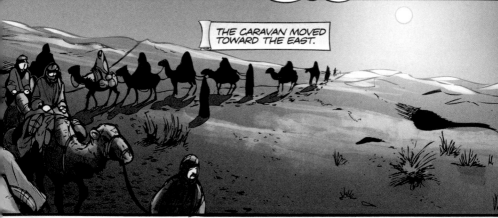

THE CARAVAN MOVED TOWARD THE EAST.

EVERYONE IS SO QUIET.

I HAVE CROSSED THE DESERT MANY TIMES.

BUT THE DESERT IS SO HUGE, AND THE HORIZON SO DISTANT, THAT THEY MAKE A PERSON FEEL SMALL, AND AS IF HE SHOULD REMAIN SILENT.

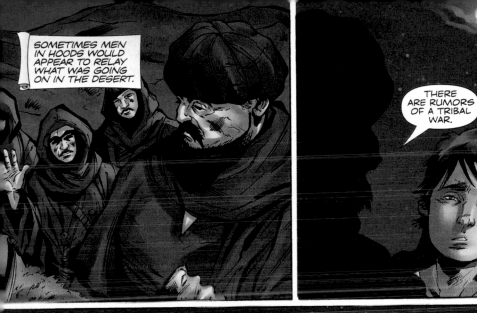

SOMETIMES MEN IN HOODS WOULD APPEAR TO RELAY WHAT WAS GOING ON IN THE DESERT.

THERE ARE RUMORS OF A TRIBAL WAR.

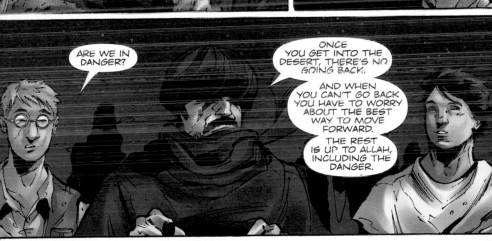

ARE WE IN DANGER?

ONCE YOU GET INTO THE DESERT, THERE'S NO GOING BACK.

AND WHEN YOU CAN'T GO BACK YOU HAVE TO WORRY ABOUT THE BEST WAY TO MOVE FORWARD.

THE REST IS UP TO ALLAH, INCLUDING THE DANGER.

MAKTUB!

YOU SHOULD PAY MORE ATTENTION TO THE CARAVAN.

AND YOU SHOULD READ MORE BOOKS ABOUT THE WORLD.

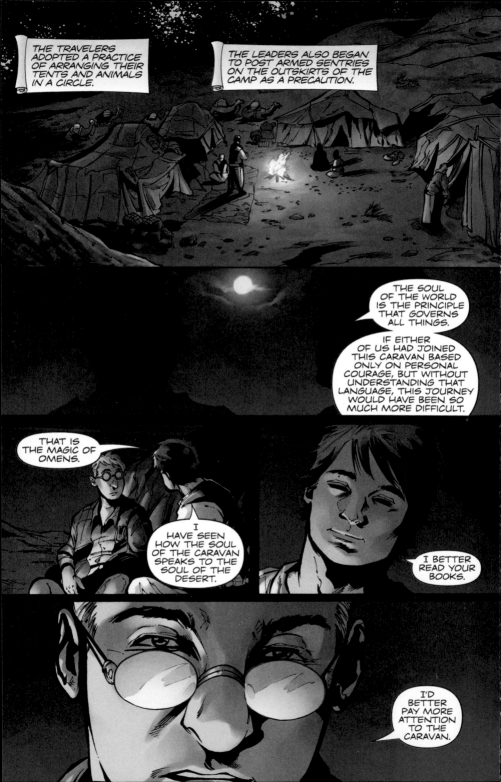

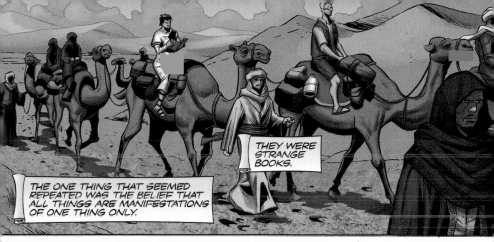

THEY WERE STRANGE BOOKS.

THE ONE THING THAT SEEMED REPEATED WAS THE BELIEF THAT ALL THINGS ARE MANIFESTATIONS OF ONE THING ONLY.

I DON'T GET ANY OF THIS.

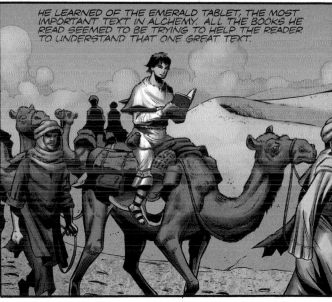

HE LEARNED OF THE EMERALD TABLET, THE MOST IMPORTANT TEXT IN ALCHEMY. ALL THE BOOKS HE READ SEEMED TO BE TRYING TO HELP THE READER TO UNDERSTAND THAT ONE GREAT TEXT.

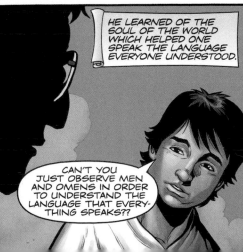

HE LEARNED OF THE SOUL OF THE WORLD WHICH HELPED ONE SPEAK THE LANGUAGE EVERYONE UNDERSTOOD.

CAN'T YOU JUST OBSERVE MEN AND OMENS IN ORDER TO UNDERSTAND THE LANGUAGE THAT EVERYTHING SPEAKS??

YOU HAVE A MANIA FOR SIMPLIFYING EVERYTHING.

ALCHEMY IS A SERIOUS DISCIPLINE. YOU MUST FOLLOW EVERYTHING THE MASTERS DID EXACTLY.

WHY IS EVERYTHING SO COMPLICATED?

SO THAT THOSE WHO HAVE THE PATIENCE FOR UNDERSTANDING CAN UNDERSTAND.

THAT'S WHY I AM HERE. I HAVE THE DEDICATION TO SEEK OUT AN ALCHEMIST TO HELP ME WITH MY ALCHEMY.

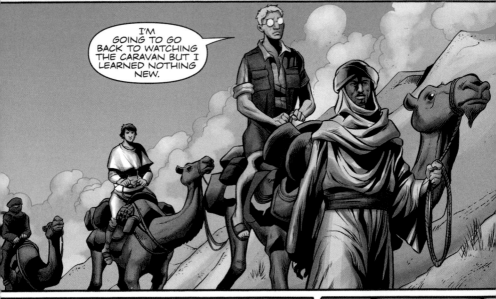

I'M GOING TO GO BACK TO WATCHING THE CARAVAN BUT I LEARNED NOTHING NEW.

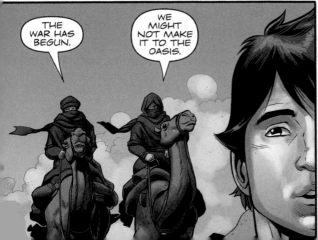

THE WAR HAS BEGUN.

WE MIGHT NOT MAKE IT TO THE OASIS.

THE TALK OF WAR IS GETTING MORE AND MORE FREQUENT.

I AM DONE WITH THE BOOKS.

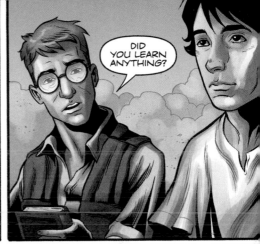

DID YOU LEARN ANYTHING?

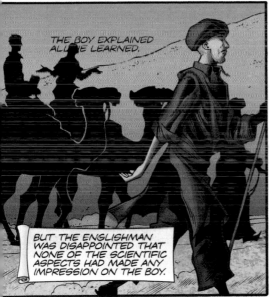

THE BOY EXPLAINED ALL HE LEARNED.

BUT THE ENGLISHMAN WAS DISAPPOINTED THAT NONE OF THE SCIENTIFIC ASPECTS HAD MADE ANY IMPRESSION ON THE BOY.

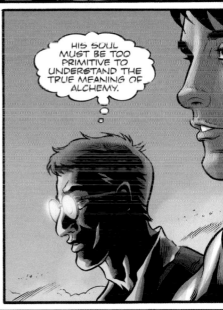

HIS SOUL MUST BE TOO PRIMITIVE TO UNDERSTAND THE TRUE MEANING OF ALCHEMY.

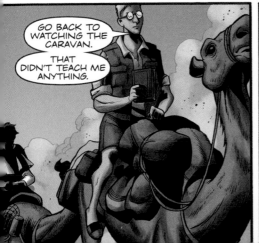

GO BACK TO WATCHING THE CARAVAN.

THAT DIDN'T TEACH ME ANYTHING.

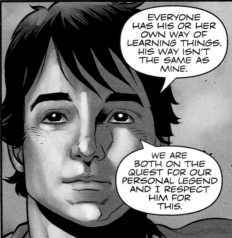

EVERYONE HAS HIS OR HER OWN WAY OF LEARNING THINGS. HIS WAY ISN'T THE SAME AS MINE.

WE ARE BOTH ON THE QUEST FOR OUR PERSONAL LEGEND AND I RESPECT HIM FOR THIS.

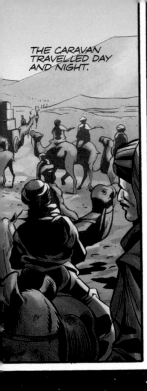

THE CARAVAN TRAVELLED DAY AND NIGHT.

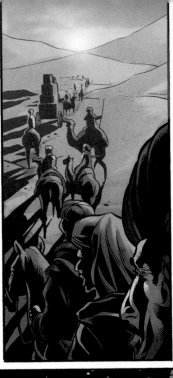

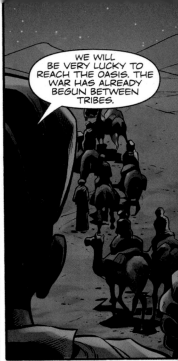

WE WILL BE VERY LUCKY TO REACH THE OASIS. THE WAR HAS ALREADY BEGUN BETWEEN TRIBES.

I DON'T LIVE IN THE PAST OR FUTURE. I'M INTERESTED IN ONLY THE PRESENT.

LIFE WILL BE PARTY FOR YOU, A GRAND BANQUET, BECAUSE LIFE IS THE MOMENT WE ARE LIVING RIGHT NOW.

IT'S THE OASIS-- LOOK!

THE BOY AWOKE AS THE SUN ROSE.

THEY HAD REACHED THE OASIS.

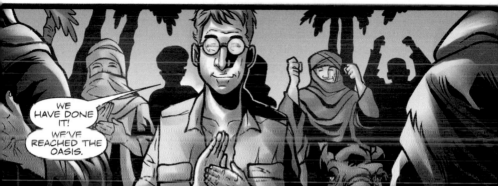

WE HAVE DONE IT! WE'VE REACHED THE OASIS.

PEOPLE WERE SHOUTING AT THE NEW ARRIVALS WITH EXCITEMENT.

WELCOME!

THANK YOU!

WELCOME, MY FRIEND!

THANK YOU.

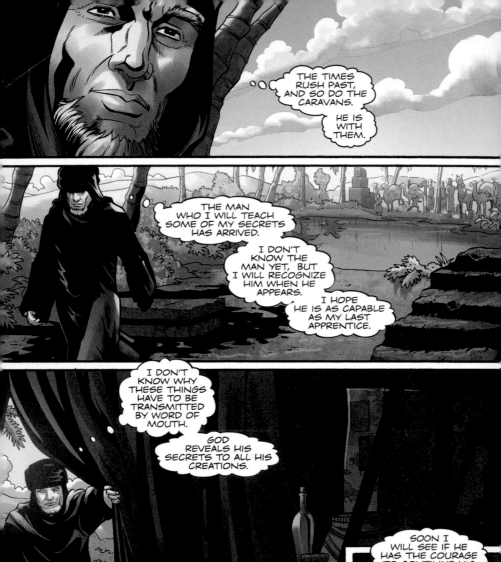

THE TIMES RUSH PAST, AND SO DO THE CARAVANS.

HE IS WITH THEM.

THE MAN WHO I WILL TEACH SOME OF MY SECRETS HAS ARRIVED.

I DON'T KNOW THE MAN YET, BUT I WILL RECOGNIZE HIM WHEN HE APPEARS.

I HOPE HE IS AS CAPABLE AS MY LAST APPRENTICE.

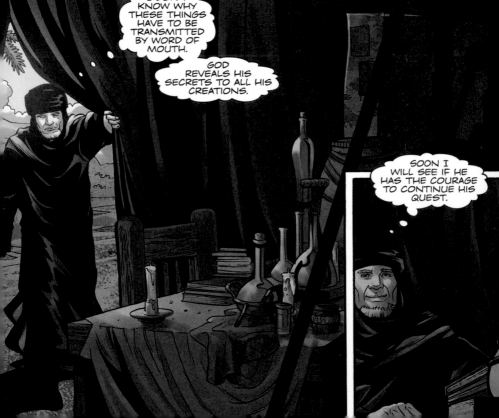

I DON'T KNOW WHY THESE THINGS HAVE TO BE TRANSMITTED BY WORD OF MOUTH.

GOD REVEALS HIS SECRETS TO ALL HIS CREATIONS.

SOON I WILL SEE IF HE HAS THE COURAGE TO CONTINUE HIS QUEST.

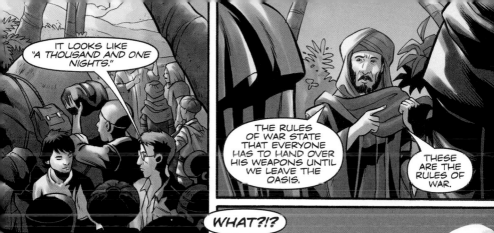

IT LOOKS LIKE "A THOUSAND AND ONE NIGHTS."

THE RULES OF WAR STATE THAT EVERYONE HAS TO HAND OVER HIS WEAPONS UNTIL WE LEAVE THE OASIS.

THESE ARE THE RULES OF WAR.

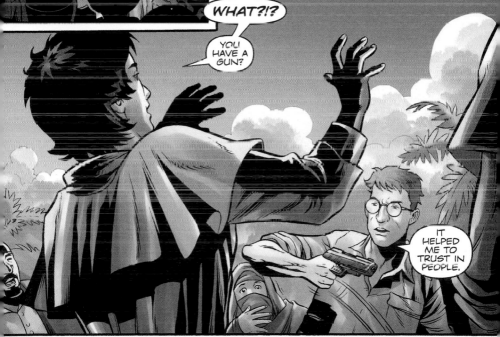

WHAT?!?

YOU HAVE A GUN?

IT HELPED ME TO TRUST IN PEOPLE.

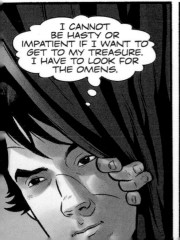

I CANNOT BE HASTY OR IMPATIENT IF I WANT TO GET TO MY TREASURE. I HAVE TO LOOK FOR THE OMENS.

I WILL EAT WHEN IT'S TIME TO EAT.

AND MOVE ALONG WHEN IT'S TIME TO MOVE ALONG.

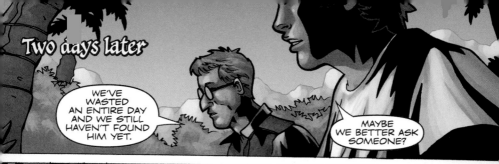

WE'VE WASTED AN ENTIRE DAY AND WE STILL HAVEN'T FOUND HIM YET.

MAYBE WE BETTER ASK SOMEONE?

GOOD AFTERNOON, MA'AM. I'M TRYING TO FIND WHERE THE ALCHEMIST LIVES HERE AT THE OASIS.

I DON'T KNOW WHO THAT IS.

YOU MUST NOT TALK TO WOMEN DRESSED IN BLACK-- THEY ARE MARRIED AND YOU SHOULD RESPECT TRADITION.

I NEVER HEARD OF THE ALCHEMIST BEFORE. MAYBE NO ONE HERE HAS EITHER.

THAT'S IT. WE SHOULD ASK WHO CURES PEOPLE'S ILLNESSES.

ASK THIS MAN WHO IS APPROACHING.

DO YOU KNOW SOME-ONE WHO CURES ILLNESSES?

ALLAH CURES OUR ILLNESSES.

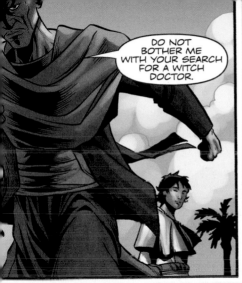

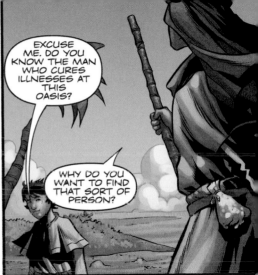

DO NOT BOTHER ME WITH YOUR SEARCH FOR A WITCH DOCTOR.

EXCUSE ME. DO YOU KNOW THE MAN WHO CURES ILLNESSES AT THIS OASIS?

WHY DO YOU WANT TO FIND THAT SORT OF PERSON?

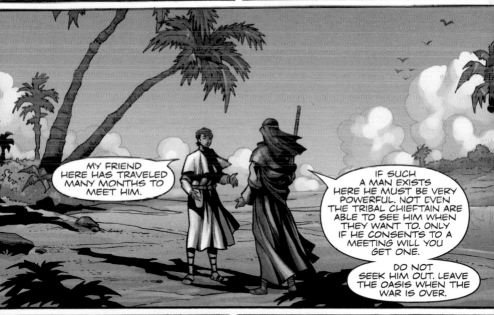

MY FRIEND HERE HAS TRAVELED MANY MONTHS TO MEET HIM.

IF SUCH A MAN EXISTS HERE HE MUST BE VERY POWERFUL. NOT EVEN THE TRIBAL CHIEFTAIN ARE ABLE TO SEE HIM WHEN THEY WANT TO. ONLY IF HE CONSENTS TO A MEETING WILL YOU GET ONE.

DO NOT SEEK HIM OUT. LEAVE THE OASIS WHEN THE WAR IS OVER.

I THINK WE ARE ON THE RIGHT TRACK.

HOPEFULLY THE NEXT PERSON CAN HELP ME FIND HIM.

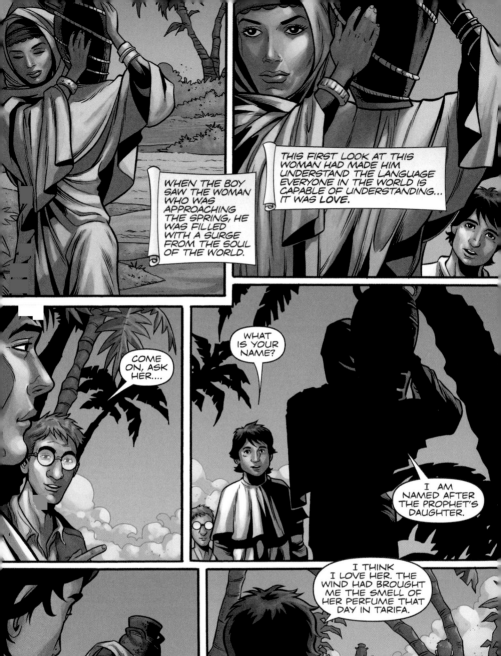
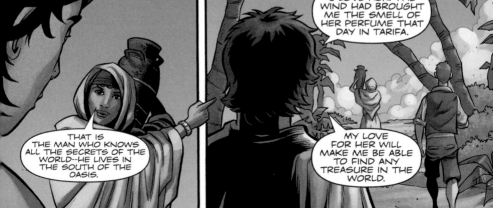

THE NEXT DAY, THE BOY RETURNED TO THE SPRING HOPING TO SEE THE GIRL.

OH? IT'S HIM.

I FOUND HIM. HE TOLD ME I SHOULD TRY TO TRANSFORM LEAD INTO GOLD. THAT'S ALL HE SAID. GO AND TRY.

SO GO AND TRY.

THAT'S WHAT I'M GOING TO GO DO. I'M GOING TO START NOW.

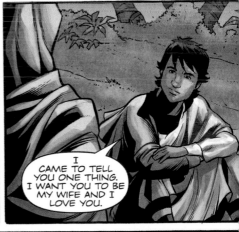

I CAME TO TELL YOU ONE THING. I WANT YOU TO BE MY WIFE AND I LOVE YOU.

I AM GOING TO WAIT HERE FOR YOU EVERYDAY.

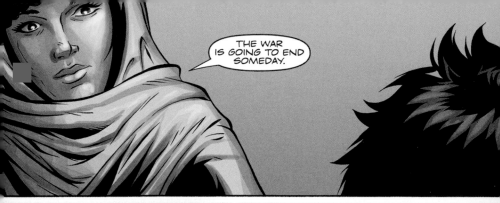

THE WAR IS GOING TO END SOMEDAY.

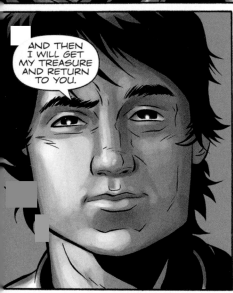

AND THEN I WILL GET MY TREASURE AND RETURN TO YOU.

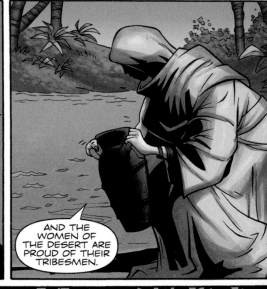

AND THE WOMEN OF THE DESERT ARE PROUD OF THEIR TRIBESMEN.

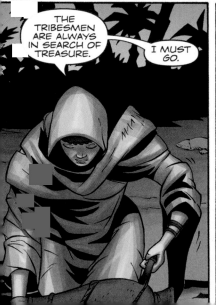

THE TRIBESMEN ARE ALWAYS IN SEARCH OF TREASURE.

I MUST GO.

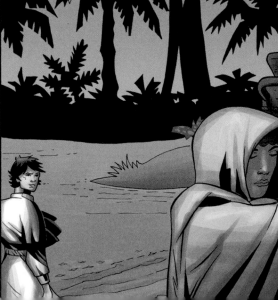

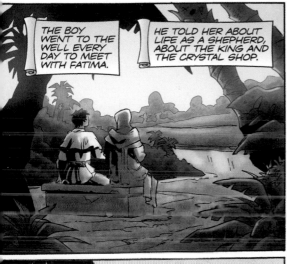

THE BOY WENT TO THE WELL EVERY DAY TO MEET WITH FATIMA.

HE TOLD HER ABOUT LIFE AS A SHEPHERD, ABOUT THE KING AND THE CRYSTAL SHOP.

THEY BECAME FRIENDS, AND EXCEPT FOR THE FIFTEEN MINUTES HE SPENT WITH HER, EACH DAY SEEMED LIKE IT WOULD NEVER PASS.

HASSAN, THE LEADER OF THE CARAVAN, HAS CALLED US ALL TO A MEETING.

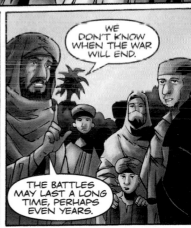

WE DON'T KNOW WHEN THE WAR WILL END.

THE BATTLES MAY LAST A LONG TIME, PERHAPS EVEN YEARS.

THESE TYPE OF BATTLES MIGHT LAST A LONG TIME BECAUSE ALLAH IS ON BOTH SIDES.

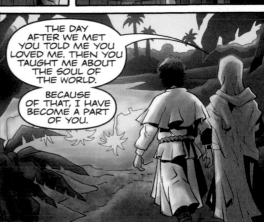

THE DAY AFTER WE MET YOU TOLD ME YOU LOVED ME. THEN YOU TAUGHT ME ABOUT THE SOUL OF THE WORLD.

BECAUSE OF THAT, I HAVE BECOME A PART OF YOU.

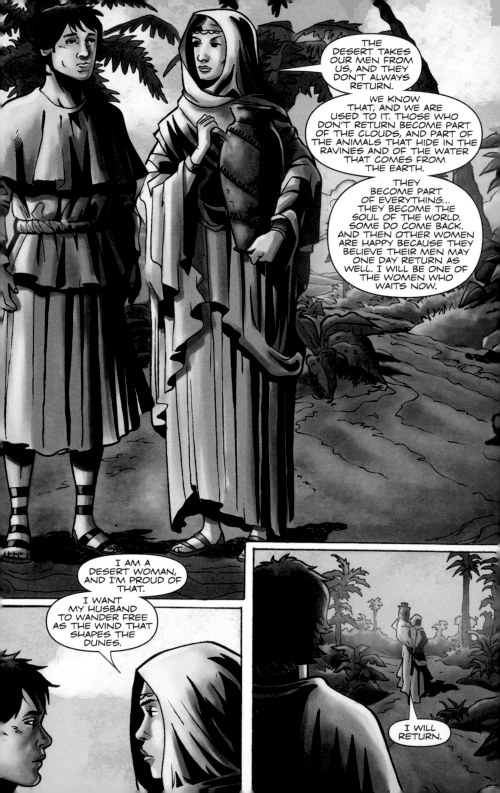

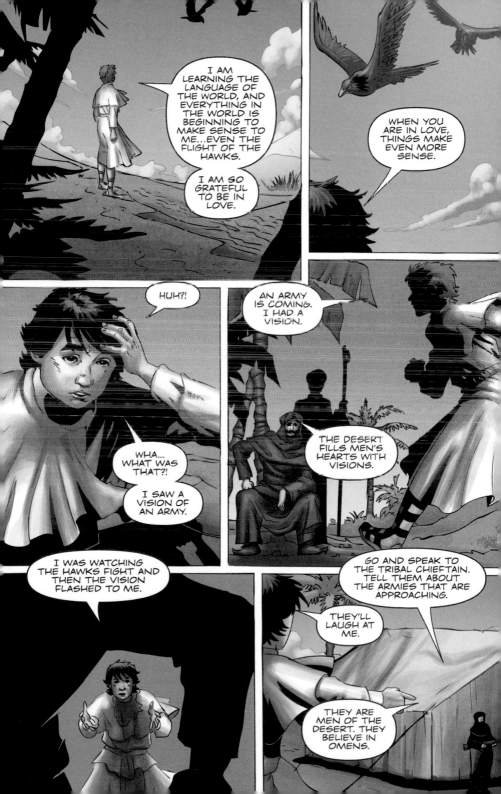

I WANT TO SEE THE CHIEFTAINS. I'VE BROUGHT OMENS FROM THE DESERT.

TELL ME OF THESE OMENS.

THE BOY TOLD THE YOUNGER MAN WHAT HE HAD SEEN.

WAIT HERE.

BOY.

HUH?

YOU MAY ENTER.

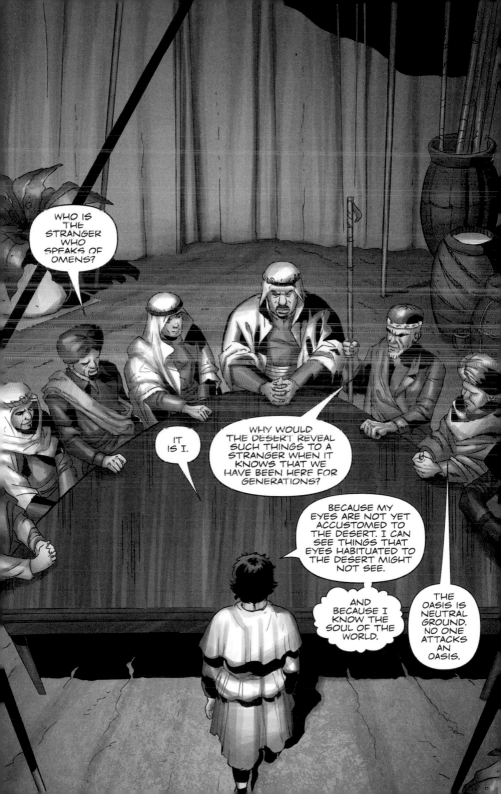

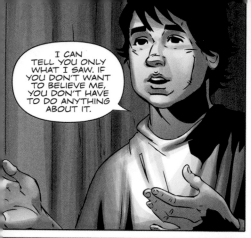

I CAN TELL YOU ONLY WHAT I SAW. IF YOU DON'T WANT TO BELIEVE ME, YOU DON'T HAVE TO DO ANYTHING ABOUT IT.

THE MEN FELL INTO AN ANIMATED DISCUSSION.

THE MAN AT THE CENTER SMILED ALMOST IMPERCEPTIBLY, AND THE BOY FELT BETTER.

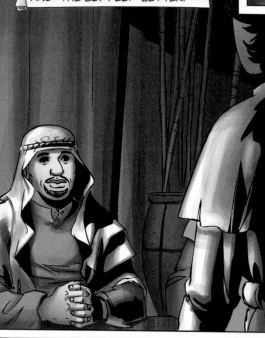

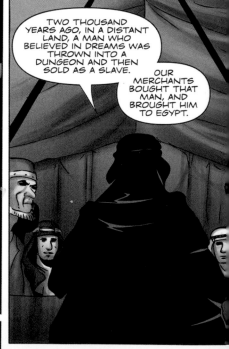

TWO THOUSAND YEARS AGO, IN A DISTANT LAND, A MAN WHO BELIEVED IN DREAMS WAS THROWN INTO A DUNGEON AND THEN SOLD AS A SLAVE. OUR MERCHANTS BOUGHT THAT MAN, AND BROUGHT HIM TO EGYPT.

ALL OF US KNOW THAT WHOEVER BELIEVES IN DREAMS ALSO KNOWS HOW TO INTERPRET THEM.

WHEN THE PHARAOH DREAMED OF COWS THAT WERE THIN AND COWS THAT WERE FAT, THIS MAN I'M SPEAKING OF RESCUED EGYPT FROM FAMINE.

HIS NAME WAS JOSEPH.

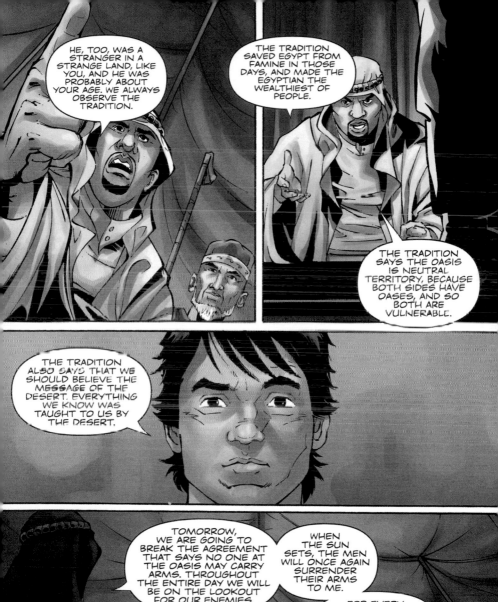

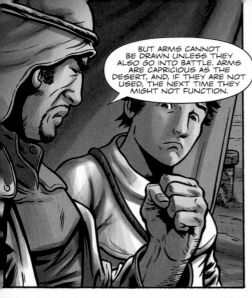

BUT ARMS CANNOT BE DRAWN UNLESS THEY ALSO GO INTO BATTLE. ARMS ARE CAPRICIOUS AS THE DESERT, AND, IF THEY ARE NOT USED, THE NEXT TIME THEY MIGHT NOT FUNCTION.

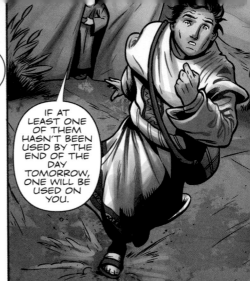

IF AT LEAST ONE OF THEM HASN'T BEEN USED BY THE END OF THE DAY TOMORROW, ONE WILL BE USED ON YOU.

WHUMP
WHUMP

WHUMP
WHUMP

HUH?

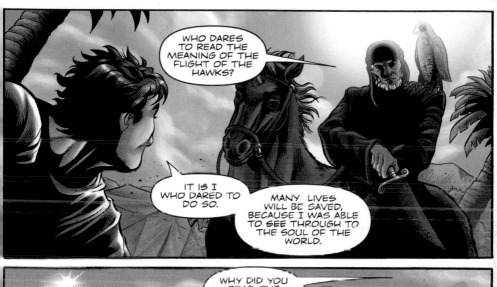

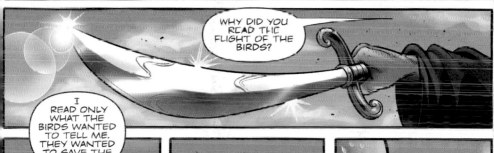

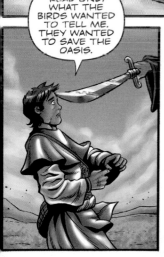
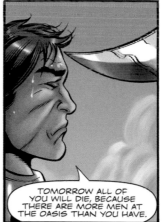

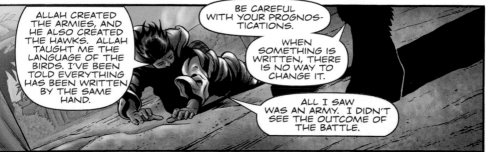

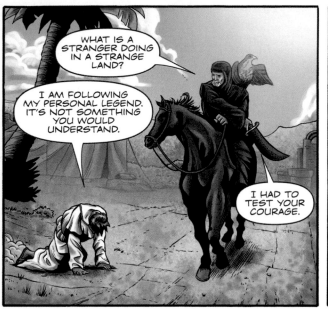

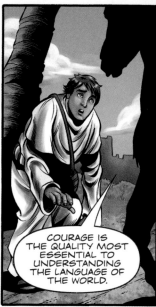

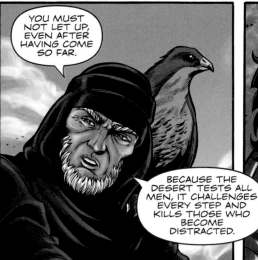

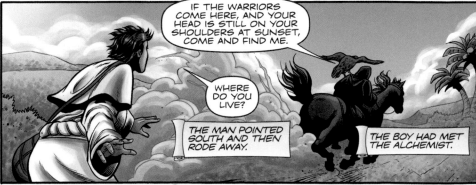

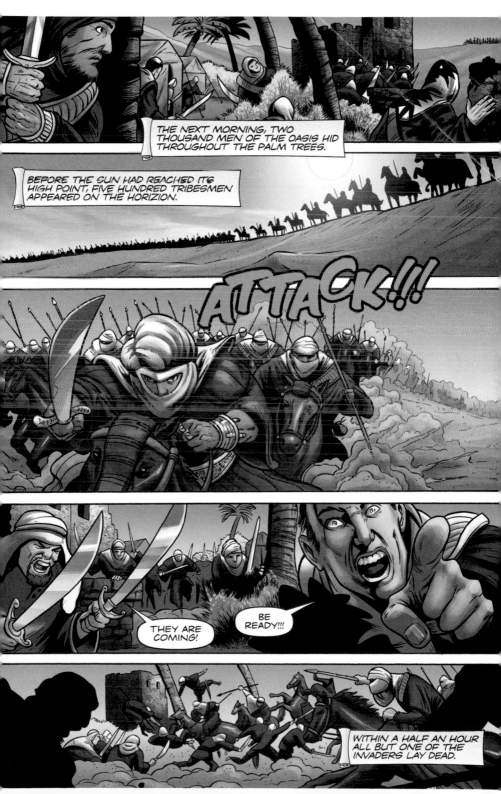

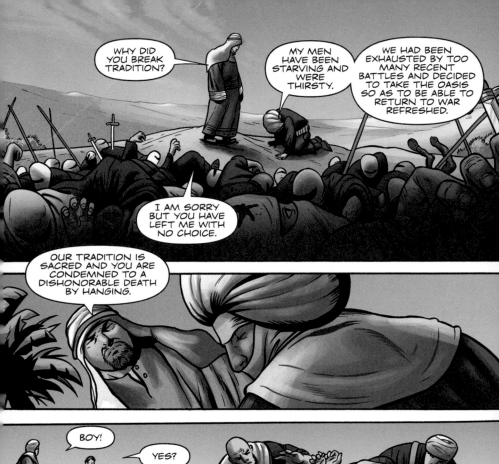

WHY DID YOU BREAK TRADITION?

MY MEN HAVE BEEN STARVING AND WERE THIRSTY.

WE HAD BEEN EXHAUSTED BY TOO MANY RECENT BATTLES AND DECIDED TO TAKE THE OASIS SO AS TO BE ABLE TO RETURN TO WAR REFRESHED.

I AM SORRY BUT YOU HAVE LEFT ME WITH NO CHOICE.

OUR TRADITION IS SACRED AND YOU ARE CONDEMNED TO A DISHONORABLE DEATH BY HANGING.

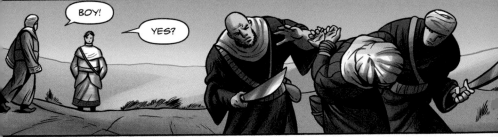

BOY!

YES?

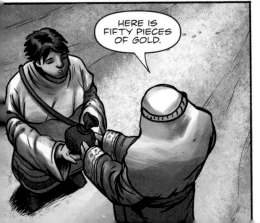

HERE IS FIFTY PIECES OF GOLD.

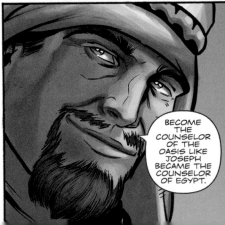

BECOME THE COUNSELOR OF THE OASIS LIKE JOSEPH BECAME THE COUNSELOR OF EGYPT.

Later.

THAT MUST BE IT.

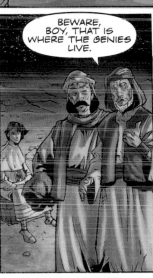

BEWARE, BOY, THAT IS WHERE THE GENIES LIVE.

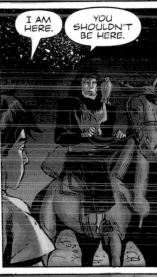

I AM HERE.

YOU SHOULDN'T BE HERE.

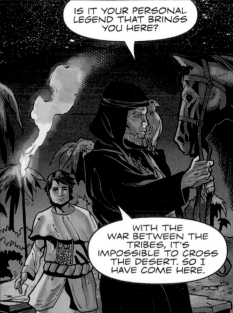

IS IT YOUR PERSONAL LEGEND THAT BRINGS YOU HERE?

WITH THE WAR BETWEEN THE TRIBES, IT'S IMPOSSIBLE TO CROSS THE DESERT. SO I HAVE COME HERE.

COME IN, WE WILL HAVE SOMETHING TO DRINK AND EAT THESE HAWKS.

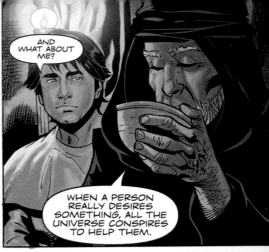

WHY DID YOU WANT TO SEE ME?

BECAUSE OF THE OMENS. THE WIND TOLD ME YOU WOULD BE COMING, AND THAT YOU WOULD NEED HELP.

AND WHAT ABOUT ME?

WHEN A PERSON REALLY DESIRES SOMETHING, ALL THE UNIVERSE CONSPIRES TO HELP THEM.

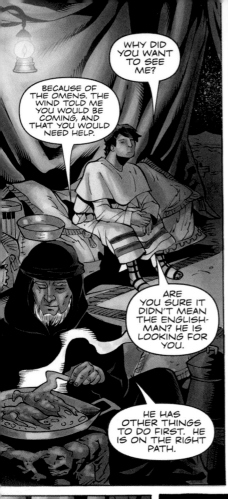

ARE YOU SURE IT DIDN'T MEAN THE ENGLISH-MAN? HE IS LOOKING FOR YOU.

HE HAS OTHER THINGS TO DO FIRST. HE IS ON THE RIGHT PATH.

DRINK AND ENJOY YOURSELF.

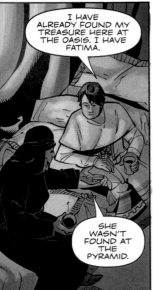

I HAVE ALREADY FOUND MY TREASURE HERE AT THE OASIS. I HAVE FATIMA.

SHE WASN'T FOUND AT THE PYRAMID.

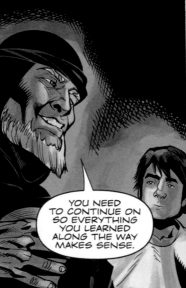

YOU NEED TO CONTINUE ON SO EVERYTHING YOU LEARNED ALONG THE WAY MAKES SENSE.

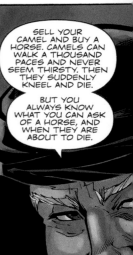

SELL YOUR CAMEL AND BUY A HORSE. CAMELS CAN WALK A THOUSAND PACES AND NEVER SEEM THIRSTY. THEN THEY SUDDENLY KNEEL AND DIE.

BUT YOU ALWAYS KNOW WHAT YOU CAN ASK OF A HORSE, AND WHEN THEY ARE ABOUT TO DIE.

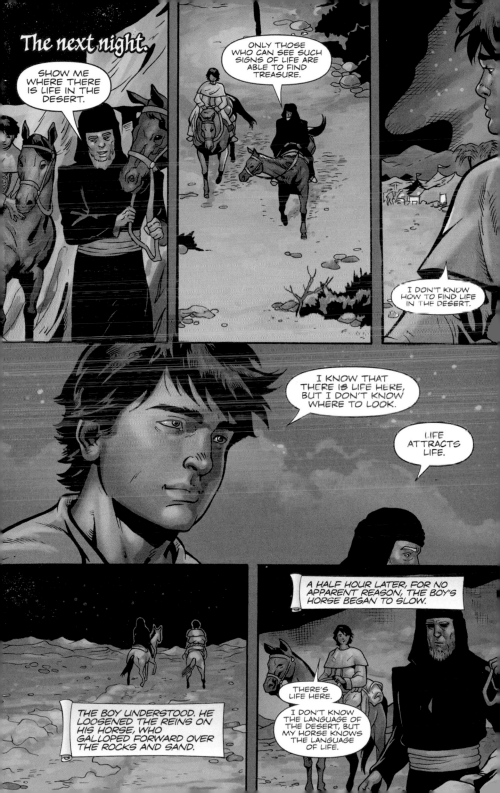

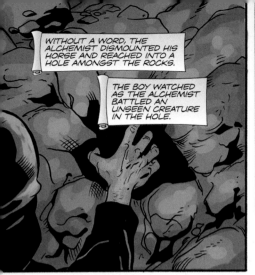

WITHOUT A WORD, THE ALCHEMIST DISMOUNTED HIS HORSE AND REACHED INTO A HOLE AMONGST THE ROCKS.

THE BOY WATCHED AS THE ALCHEMIST BATTLED AN UNSEEN CREATURE IN THE HOLE.

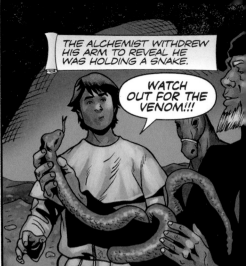

THE ALCHEMIST WITHDREW HIS ARM TO REVEAL HE WAS HOLDING A SNAKE.

WATCH OUT FOR THE VENOM!!!

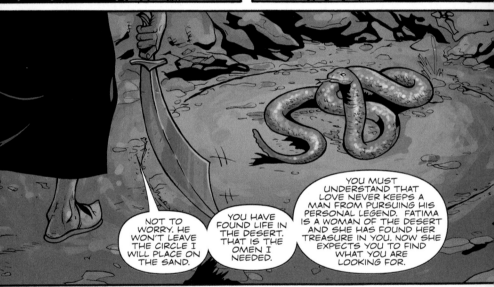

NOT TO WORRY. HE WON'T LEAVE THE CIRCLE I WILL PLACE ON THE SAND.

YOU HAVE FOUND LIFE IN THE DESERT. THAT IS THE OMEN I NEEDED.

YOU MUST UNDERSTAND THAT LOVE NEVER KEEPS A MAN FROM PURSUING HIS PERSONAL LEGEND. FATIMA IS A WOMAN OF THE DESERT AND SHE HAS FOUND HER TREASURE IN YOU. NOW SHE EXPECTS YOU TO FIND WHAT YOU ARE LOOKING FOR.

THE ALCHEMIST EXPLAINED TO THE BOY WHY HE MUST SEEK HIS PERSONAL LEGEND TO ITS COMPLETION OR HE WOULD REGRET IT FOR THE REST OF HIS LIFE.

I WILL GO WITH YOU.

WE WILL LEAVE BEFORE SUNRISE.

The next morning.

DON'T THINK ABOUT WHAT YOU LEFT BEHIND.

MEN DREAM MORE ABOUT COMING HOME THAN ABOUT LEAVING.

EVERYTHING IS WRITTEN IN THE SOUL OF THE WORLD, AND THERE IT WILL STAY FOREVER.

IF WHAT ONE FINDS IS MADE OF PURE MATTER, IT WILL NEVER SPOIL. AND ONE CAN ALWAYS COME BACK. IF WHAT YOU HAD FOUND WAS ONLY A MOMENT OF LIGHT, LIKE THE EXPLOSION OF A STAR, YOU WOULD FIND NOTHING ON YOUR RETURN.

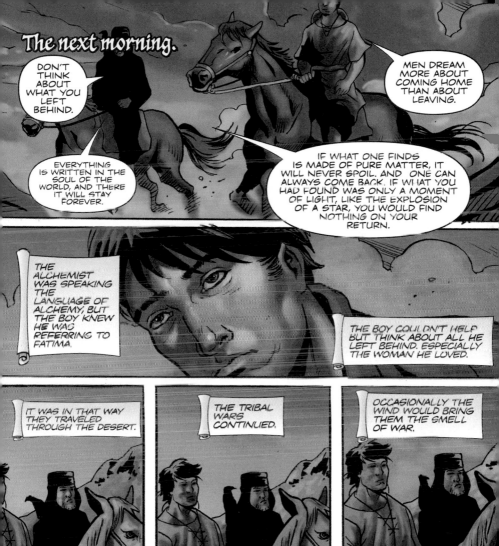

THE ALCHEMIST WAS SPEAKING THE LANGUAGE OF ALCHEMY, BUT THE BOY KNEW HE WAS REFERRING TO FATIMA.

THE BOY COULDN'T HELP BUT THINK ABOUT ALL HE LEFT BEHIND. ESPECIALLY THE WOMAN HE LOVED.

IT WAS IN THAT WAY THEY TRAVELED THROUGH THE DESERT.

THE TRIBAL WARS CONTINUED.

OCCASIONALLY THE WIND WOULD BRING THEM THE SMELL OF WAR.

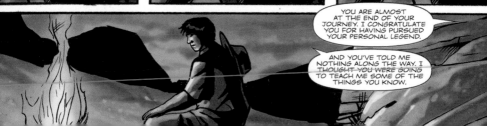

YOU ARE ALMOST AT THE END OF YOUR JOURNEY. I CONGRATULATE YOU FOR HAVING PURSUED YOUR PERSONAL LEGEND.

AND YOU'VE TOLD ME NOTHING ALONG THE WAY. I THOUGHT YOU WERE GOING TO TEACH ME SOME OF THE THINGS YOU KNOW.

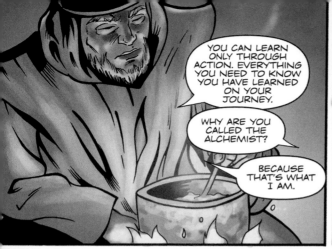

YOU CAN LEARN ONLY THROUGH ACTION. EVERYTHING YOU NEED TO KNOW YOU HAVE LEARNED ON YOUR JOURNEY.

WHY ARE YOU CALLED THE ALCHEMIST?

BECAUSE THAT'S WHAT I AM.

WHAT WAS WRITTEN ON THE EMERALD TABLET I HAD READ ABOUT IN THE BOOKS OF THE ENGLISHMAN?

THIS IS WHAT IS WRITTEN ON THE EMERALD TABLET.

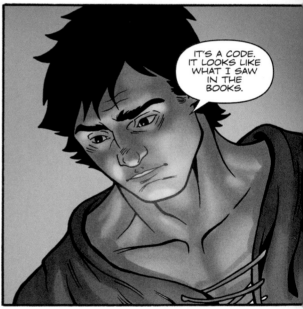

IT'S A CODE. IT LOOKS LIKE WHAT I SAW IN THE BOOKS.

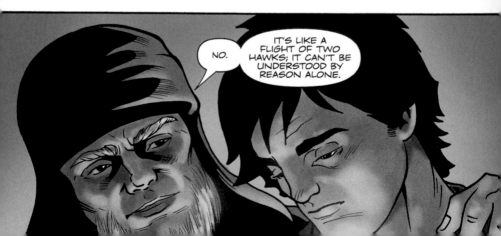

NO.

IT'S LIKE A FLIGHT OF TWO HAWKS; IT CAN'T BE UNDERSTOOD BY REASON ALONE.

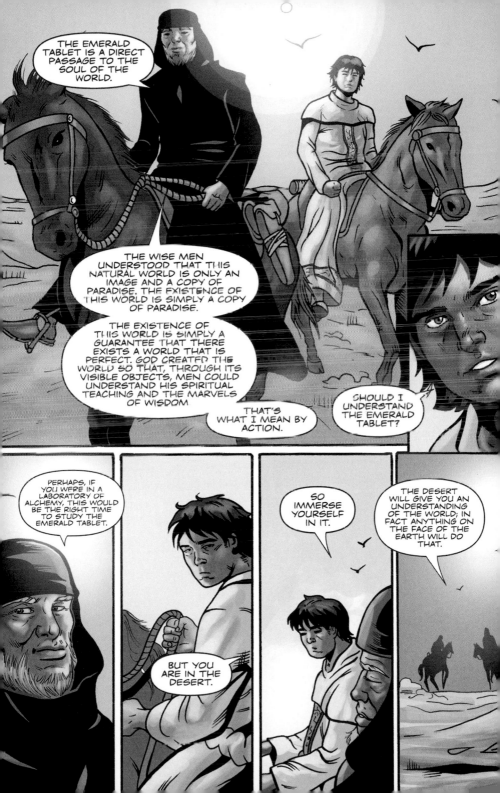

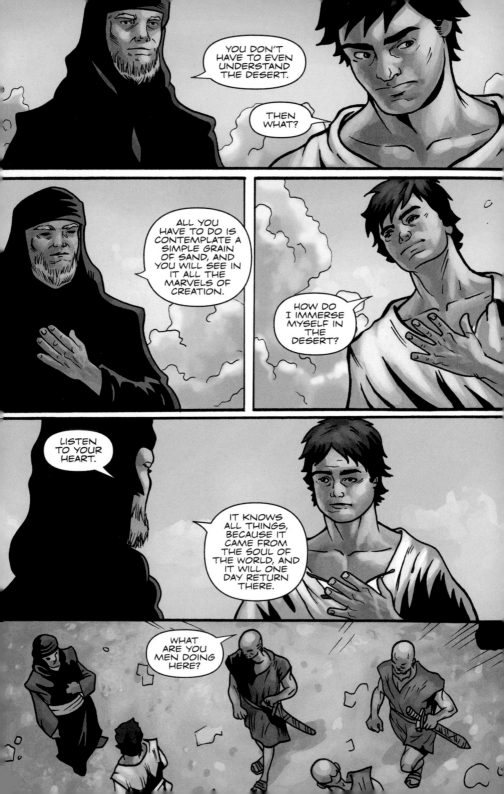

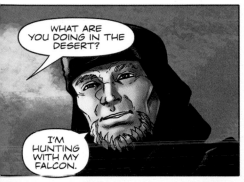

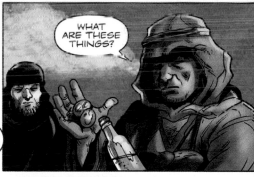

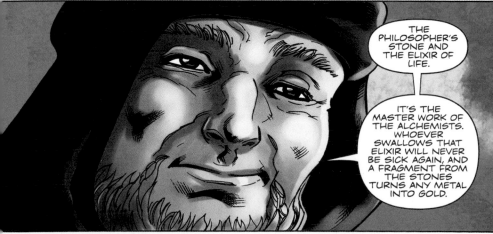

HAHAHA!

YOU MAY GO.

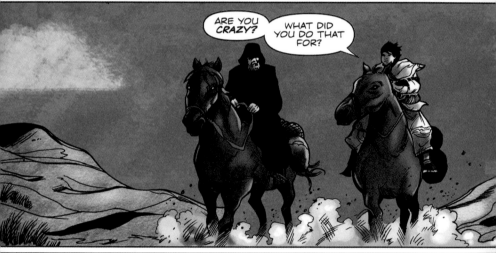

ARE YOU CRAZY?

WHAT DID YOU DO THAT FOR?

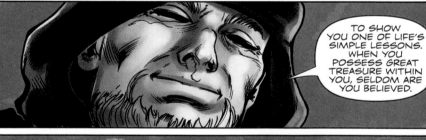

TO SHOW YOU ONE OF LIFE'S SIMPLE LESSONS. WHEN YOU POSSESS GREAT TREASURE WITHIN YOU, SELDOM ARE YOU BELIEVED.

THEY CONTINUED TO CROSS THE DESERT.

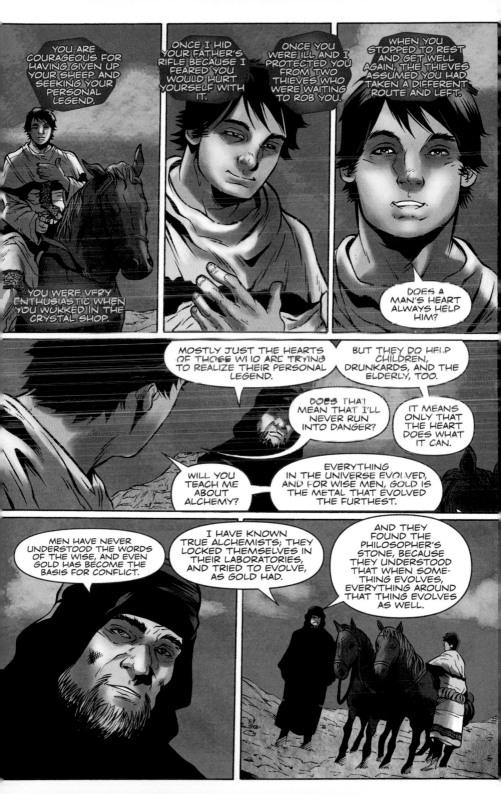

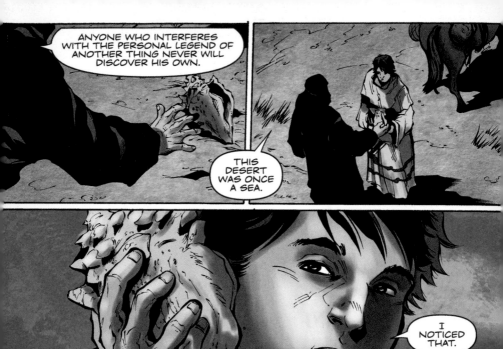

ANYONE WHO INTERFERES WITH THE PERSONAL LEGEND OF ANOTHER THING NEVER WILL DISCOVER HIS OWN.

THIS DESERT WAS ONCE A SEA.

I NOTICED THAT.

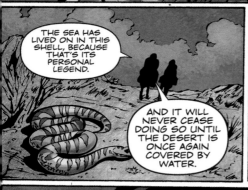

THE SEA HAS LIVED ON IN THIS SHELL, BECAUSE THAT'S ITS PERSONAL LEGEND.

AND IT WILL NEVER CEASE DOING SO UNTIL THE DESERT IS ONCE AGAIN COVERED BY WATER.

DANGER!

HMM?

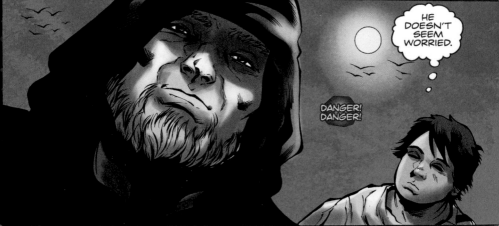

HE DOESN'T SEEM WORRIED.

DANGER! DANGER!

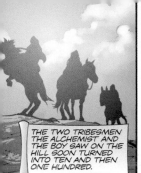

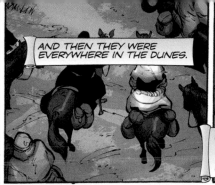

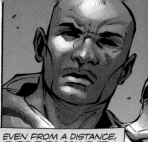

THE TWO TRIBESMEN THE ALCHEMIST AND THE BOY SAW ON THE HILL SOON TURNED INTO TEN AND THEN ONE HUNDRED.

AND THEN THEY WERE EVERYWHERE IN THE DUNES.

EVEN FROM A DISTANCE, THEIR EYES CONVEYED THE STRENGTH OF THEIR SOULS. AND THEIR EYES SPOKE OF DEATH.

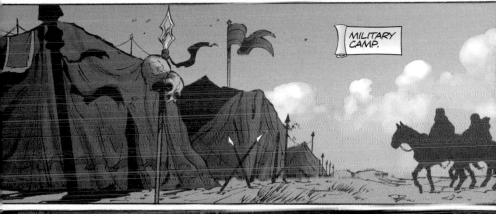

MILITARY CAMP.

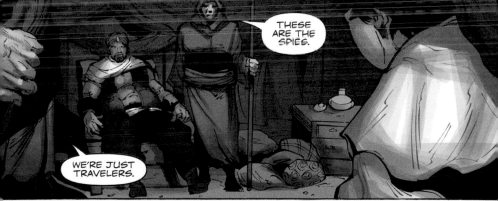

THESE ARE THE SPIES.

WE'RE JUST TRAVELERS.

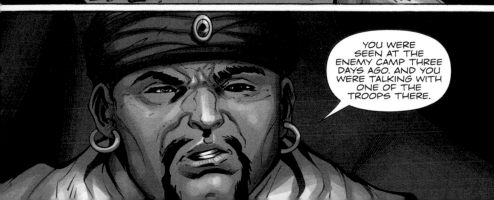

YOU WERE SEEN AT THE ENEMY CAMP THREE DAYS AGO. AND YOU WERE TALKING WITH ONE OF THE TROOPS THERE.

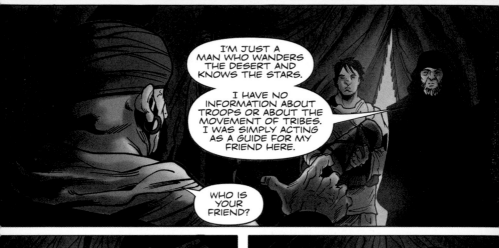

I'M JUST A MAN WHO WANDERS THE DESERT AND KNOWS THE STARS.

I HAVE NO INFORMATION ABOUT TROOPS OR ABOUT THE MOVEMENT OF TRIBES. I WAS SIMPLY ACTING AS A GUIDE FOR MY FRIEND HERE.

WHO IS YOUR FRIEND?

AN ALCHEMIST.

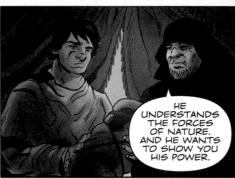

HE UNDERSTANDS THE FORCES OF NATURE. AND HE WANTS TO SHOW YOU HIS POWER.

HE HAS BROUGHT MONEY TO GIVE TO YOUR TRIBE.

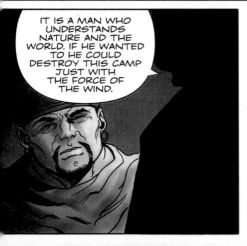

IT IS A MAN WHO UNDERSTANDS NATURE AND THE WORLD. IF HE WANTED TO HE COULD DESTROY THIS CAMP JUST WITH THE FORCE OF THE WIND.

HAHAHAH!

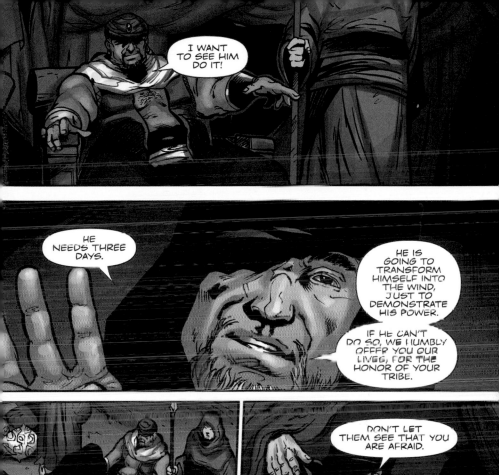

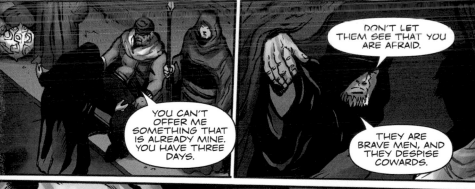

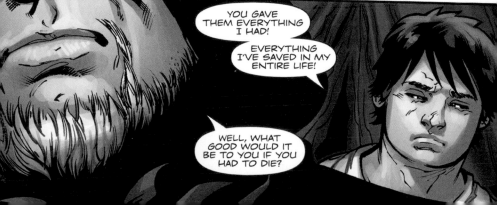

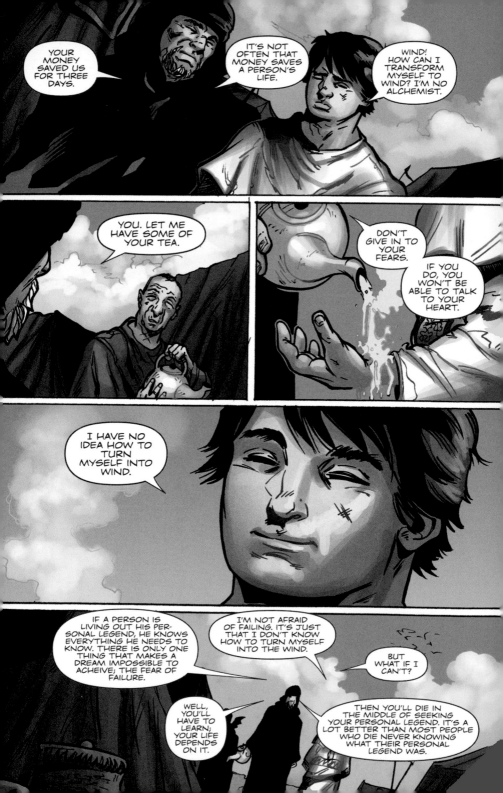

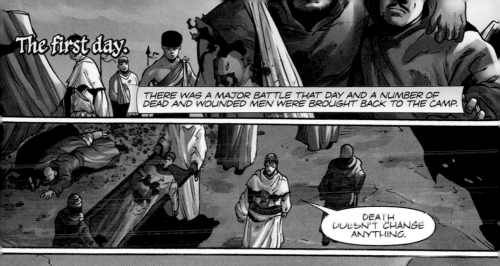

The first day.

THERE WAS A MAJOR BATTLE THAT DAY AND A NUMBER OF DEAD AND WOUNDED MEN WERE BROUGHT BACK TO THE CAMP.

DEATH DOESN'T CHANGE ANYTHING.

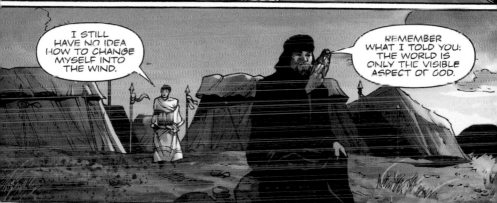

I STILL HAVE NO IDEA HOW TO CHANGE MYSELF INTO THE WIND.

REMEMBER WHAT I TOLD YOU: THE WORLD IS ONLY THE VISIBLE ASPECT OF GOD.

AND THAT WHAT ALCHEMY DOES IS TO BRING SPIRITUAL PERFECTION INTO CONTACT WITH THE MATERIAL PLANE.

WHAT ARE YOU DOING?

FEEDING MY FALCON.

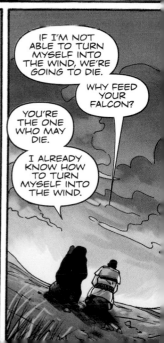

IF I'M NOT ABLE TO TURN MYSELF INTO THE WIND, WE'RE GOING TO DIE.

WHY FEED YOUR FALCON?

YOU'RE THE ONE WHO MAY DIE.

I ALREADY KNOW HOW TO TURN MYSELF INTO THE WIND.

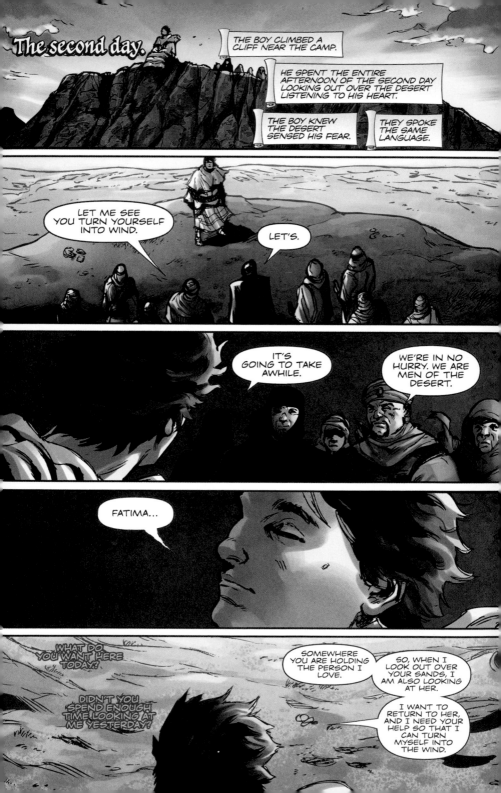

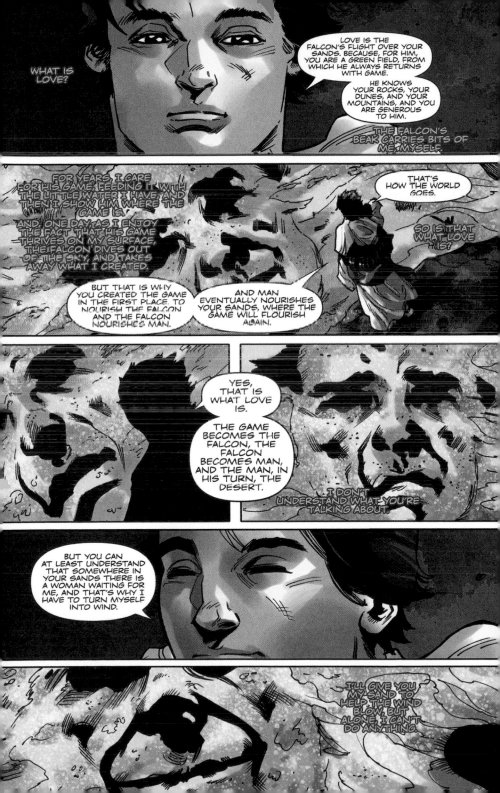

YOU HAVE TO ASK THE WIND FOR HELP.

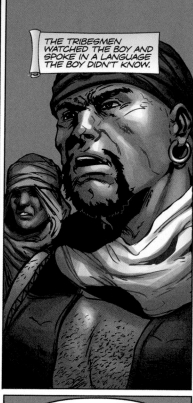

THE TRIBESMEN WATCHED THE BOY AND SPOKE IN A LANGUAGE THE BOY DIDN'T KNOW.

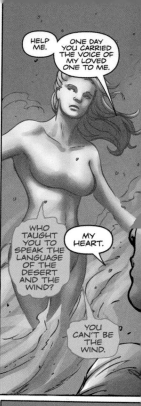

HELP ME.

ONE DAY YOU CARRIED THE VOICE OF MY LOVED ONE TO ME.

WHO TAUGHT YOU TO SPEAK THE LANGUAGE OF THE DESERT AND THE WIND?

MY HEART.

YOU CAN'T BE THE WIND.

WE'RE TWO VERY DIFFERENT THINGS.

THAT'S NOT TRUE. I LEARNED THE ALCHEMIST'S SECRETS IN MY TRAVELS.

I HAVE INSIDE ME THE WINDS, THE DESERTS, THE OCEANS, THE STARS AND EVERYTHING CREATED IN THE UNIVERSE.

WE ARE ALL MADE BY THE SAME HAND, WE HAVE THE SAME SOUL.

I HEARD WHAT YOU WERE TALKING ABOUT THE OTHER DAY WITH THE ALCHEMIST.

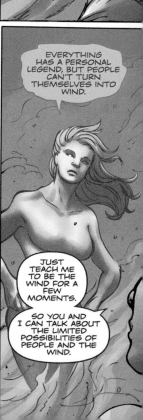

EVERYTHING HAS A PERSONAL LEGEND, BUT PEOPLE CAN'T TURN THEMSELVES INTO WIND.

JUST TEACH ME TO BE THE WIND FOR A FEW MOMENTS.

SO YOU AND I CAN TALK ABOUT THE LIMITED POSSIBILITIES OF PEOPLE AND THE WIND.

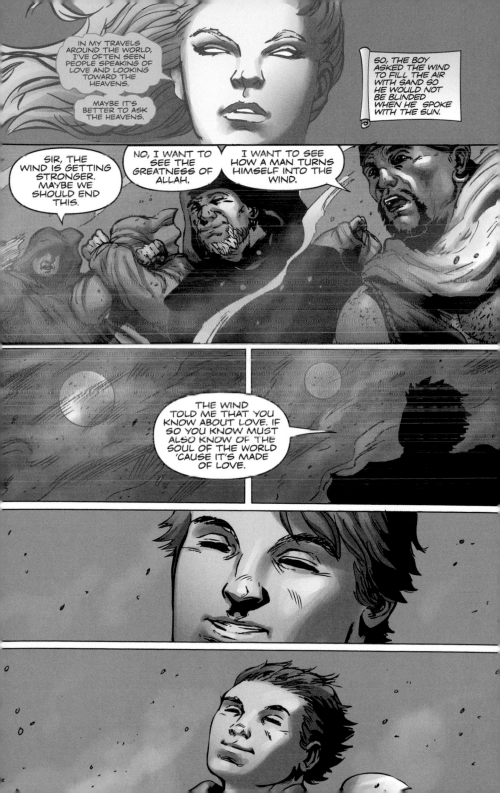

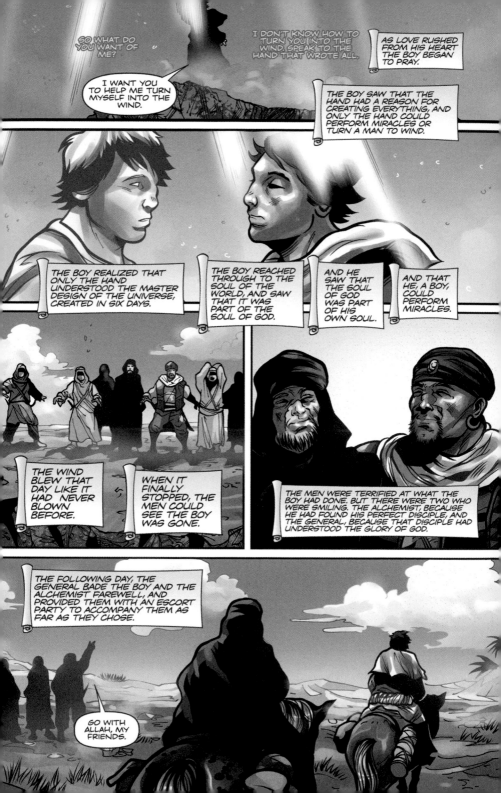

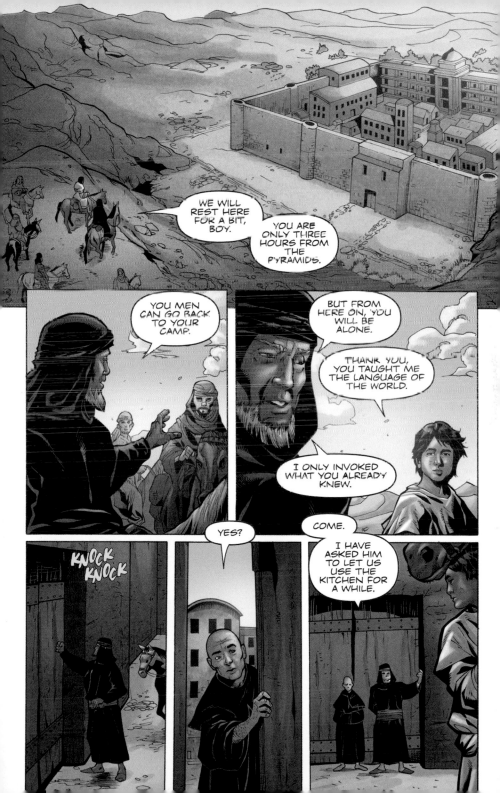

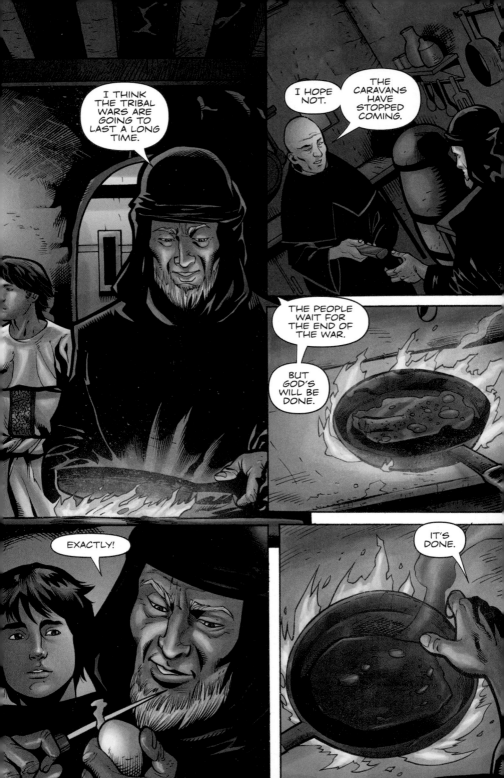

IT'S...

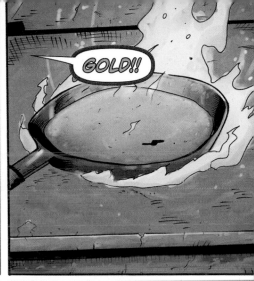

GOLD!!

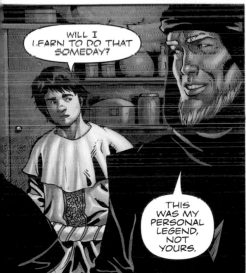

WILL I LEARN TO DO THAT SOMEDAY?

THIS WAS MY PERSONAL LEGEND, NOT YOURS.

BUT I WANTED TO SHOW YOU THAT IT WAS POSSIBLE.

SNAP!

THIS IS FOR YOU.

IT'S FOR YOUR GENEROSITY TO THE PILGRIMS.

BUT THIS PAYMENT GOES WELL BEYOND MY GENEROSITY.

DON'T SAY THAT AGAIN. LIFE MIGHT BE LISTENING, AND GIVE YOU LESS THE NEXT TIME.

AS YOU WISH, MY FRIEND.

THIS IS FOR YOU.

TO MAKE UP FOR WHAT YOU GAVE TO THE GENERAL.

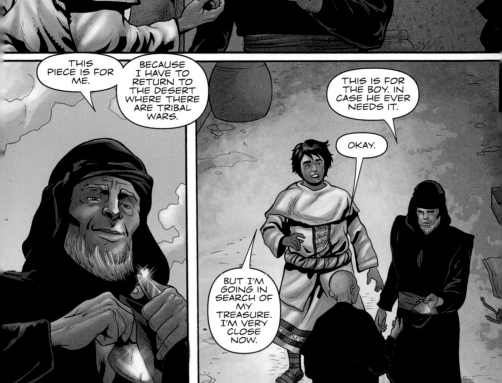

THIS PIECE IS FOR ME.

BECAUSE I HAVE TO RETURN TO THE DESERT WHERE THERE ARE TRIBAL WARS.

THIS IS FOR THE BOY. IN CASE HE EVER NEEDS IT.

OKAY.

BUT I'M GOING IN SEARCH OF MY TREASURE. I'M VERY CLOSE NOW.

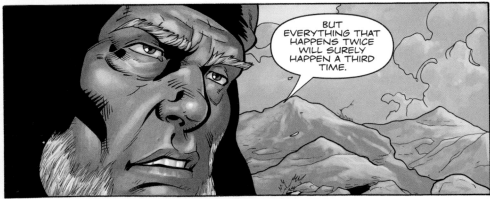

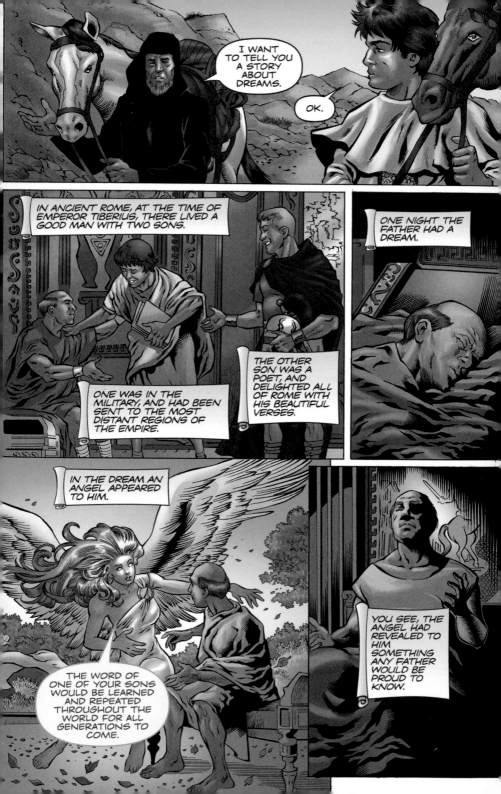

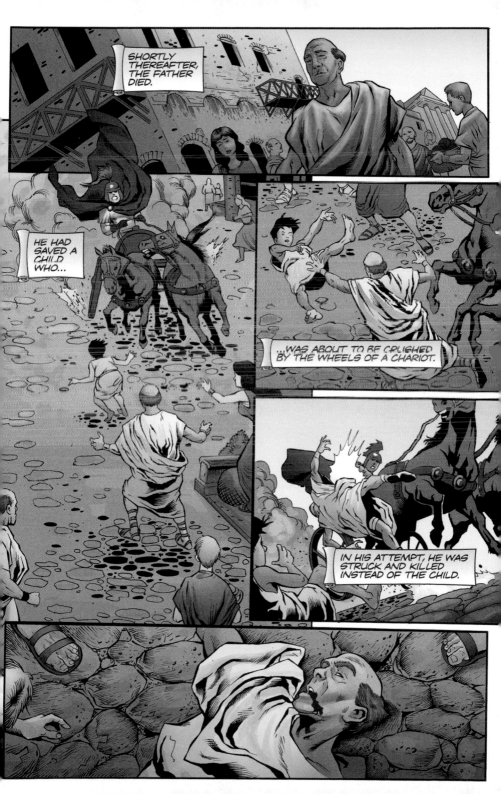

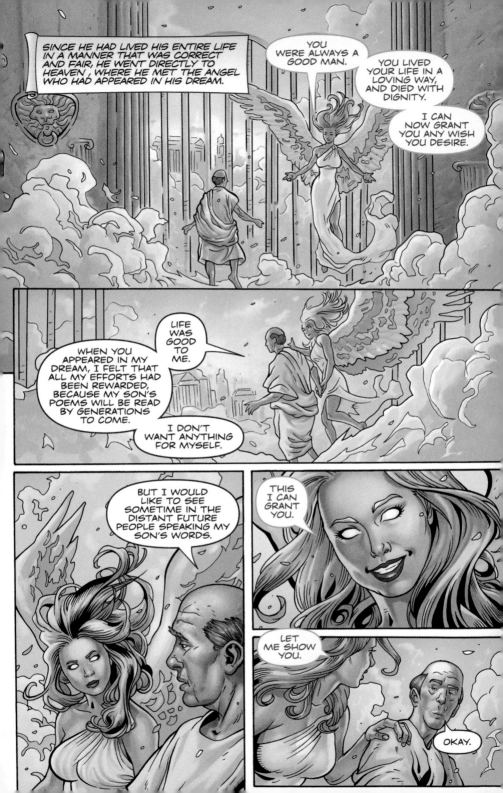

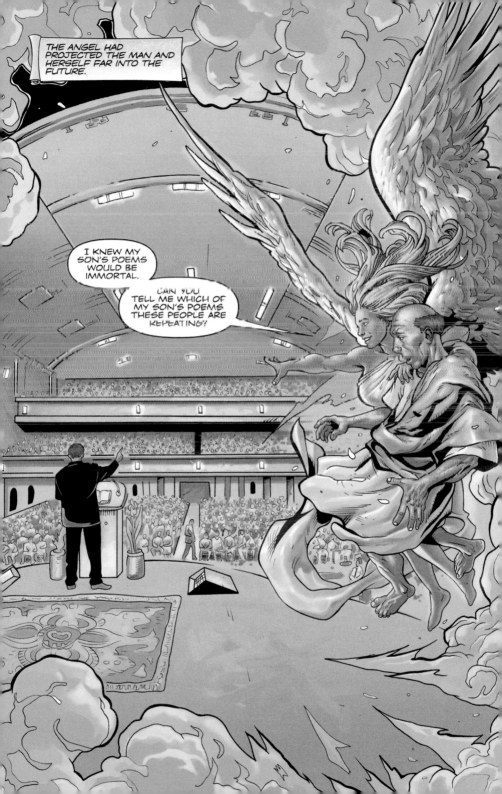

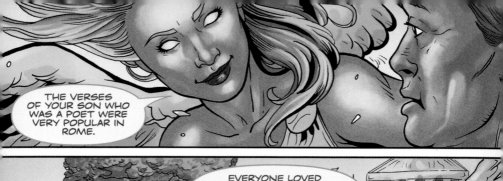

THE VERSES OF YOUR SON WHO WAS A POET WERE VERY POPULAR IN ROME.

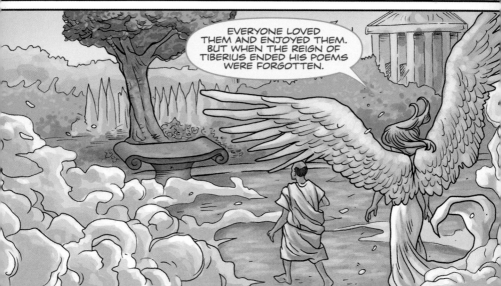

EVERYONE LOVED THEM AND ENJOYED THEM. BUT WHEN THE REIGN OF TIBERIUS ENDED HIS POEMS WERE FORGOTTEN.

THE WORDS YOU HEARD, WERE THOSE OF YOUR SON IN THE MILITARY.

WHAT?!

YOUR SON WENT TO SERVE AT A DISTANT PLACE, AND BECAME A CENTURION.

"ONE AFTERNOON, ONE OF HIS SERVANTS FELL ILL."

ARE YOU WELL, MARCUS?

YES, MY LOR...

...UGH.

MARCUS!!!

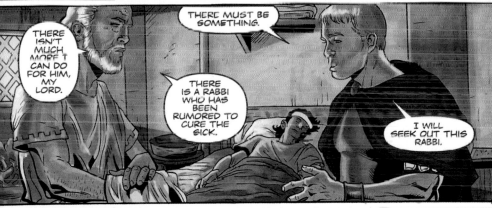
THERE MUST BE SOMETHING.

THERE ISN'T MUCH MORE I CAN DO FOR HIM, MY LORD.

THERE IS A RABBI WHO HAS BEEN RUMORED TO CURE THE SICK.

I WILL SEEK OUT THIS RABBI.

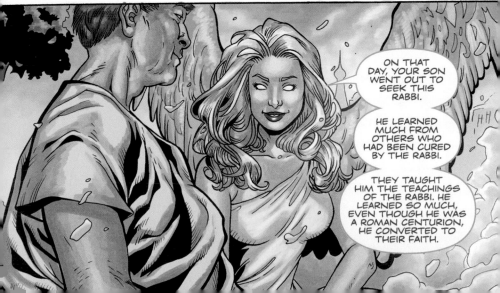
ON THAT DAY, YOUR SON WENT OUT TO SEEK THIS RABBI.

HE LEARNED MUCH FROM OTHERS WHO HAD BEEN CURED BY THE RABBI.

THEY TAUGHT HIM THE TEACHINGS OF THE RABBI. HE LEARNED SO MUCH, EVEN THOUGH HE WAS A ROMAN CENTURION, HE CONVERTED TO THEIR FAITH.

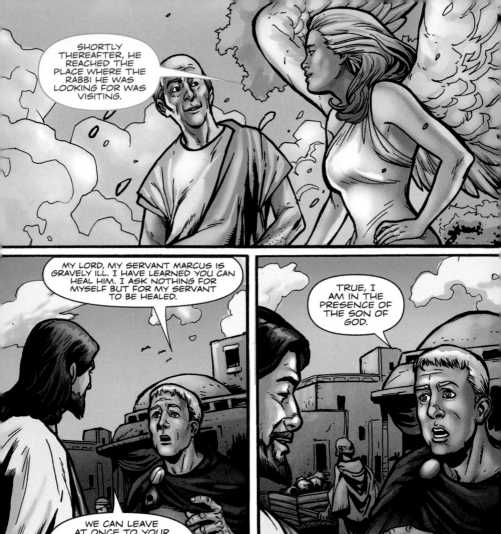

SHORTLY THEREAFTER, HE REACHED THE PLACE WHERE THE RABBI HE WAS LOOKING FOR WAS VISITING.

MY LORD, MY SERVANT MARCUS IS GRAVELY ILL. I HAVE LEARNED YOU CAN HEAL HIM. I ASK NOTHING FOR MYSELF BUT FOR MY SERVANT TO BE HEALED.

WE CAN LEAVE AT ONCE TO YOUR HOME. I WILL HELP THIS MAN YOU HAVE TRAVELED SO FAR ON BEHALF OF.

TRUE, I AM IN THE PRESENCE OF THE SON OF GOD.

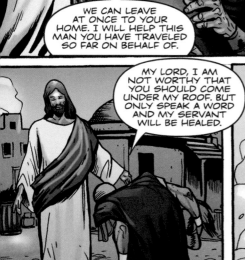

MY LORD, I AM NOT WORTHY THAT YOU SHOULD COME UNDER MY ROOF. BUT ONLY SPEAK A WORD AND MY SERVANT WILL BE HEALED.

THANK YOU.

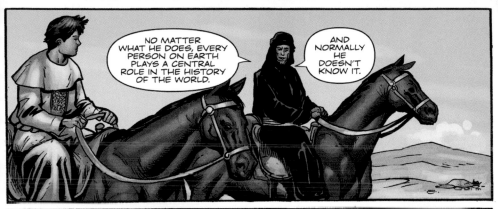

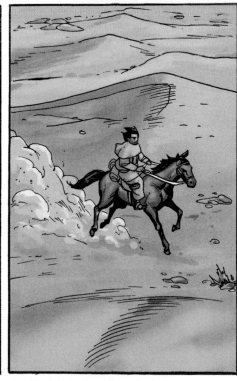

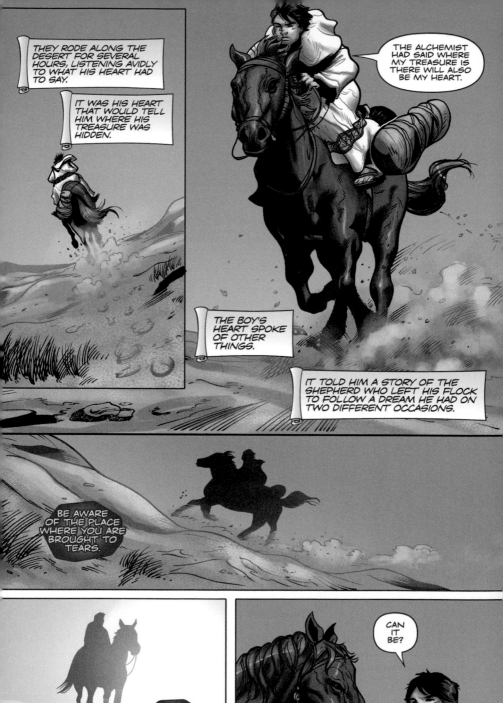

THEY RODE ALONG THE DESERT FOR SEVERAL HOURS, LISTENING AVIDLY TO WHAT HIS HEART HAD TO SAY.

IT WAS HIS HEART THAT WOULD TELL HIM WHERE HIS TREASURE WAS HIDDEN.

THE ALCHEMIST HAD SAID WHERE MY TREASURE IS THERE WILL ALSO BE MY HEART.

THE BOY'S HEART SPOKE OF OTHER THINGS.

IT TOLD HIM A STORY OF THE SHEPHERD WHO LEFT HIS FLOCK TO FOLLOW A DREAM HE HAD ON TWO DIFFERENT OCCASIONS.

BE AWARE OF THE PLACE WHERE YOU ARE BROUGHT TO TEARS.

THAT'S WHERE I AM, AND THAT'S WHERE YOUR TREASURE IS.

CAN IT BE?

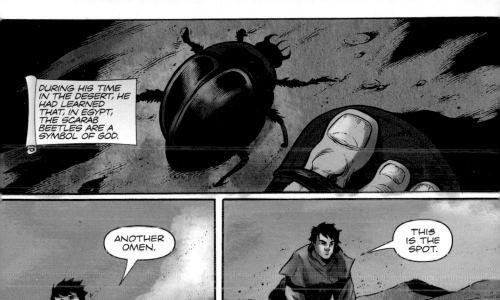

DURING HIS TIME IN THE DESERT, HE HAD LEARNED THAT, IN EGYPT, THE SCARAB BEETLES ARE A SYMBOL OF GOD.

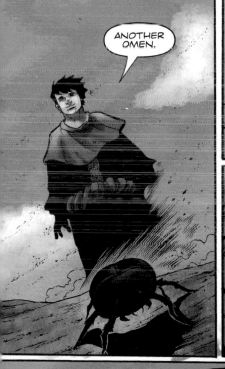

ANOTHER OMEN.

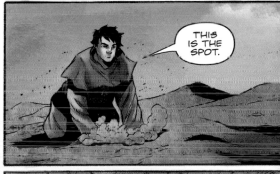

THIS IS THE SPOT.

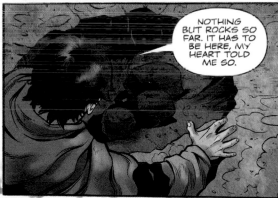

NOTHING BUT ROCKS SO FAR. IT HAS TO BE HERE, MY HEART TOLD ME SO.

HUH!

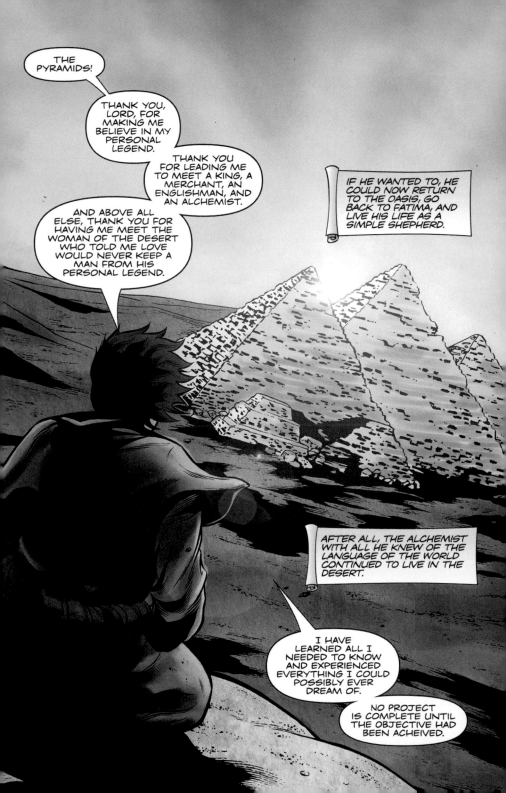

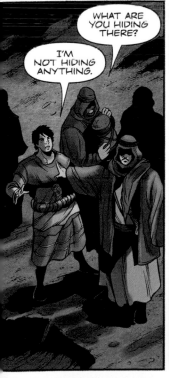

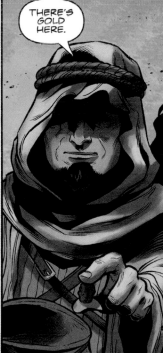

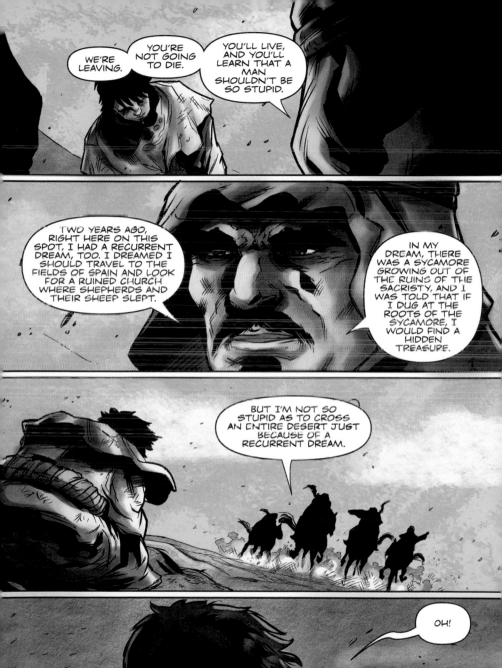

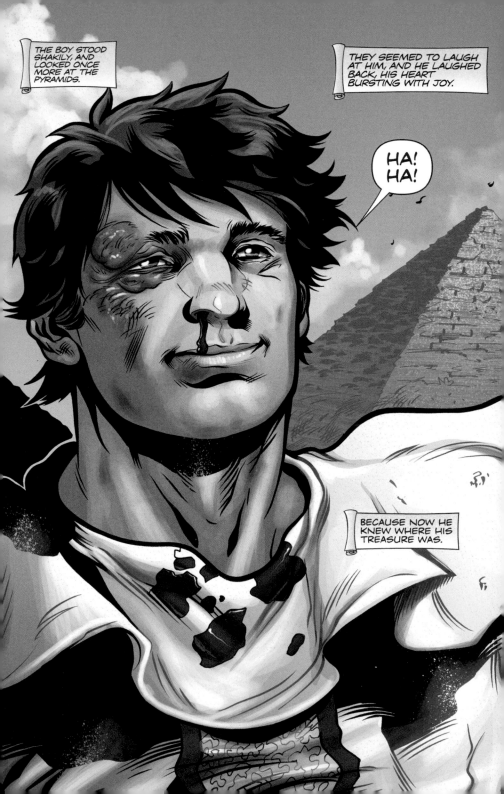

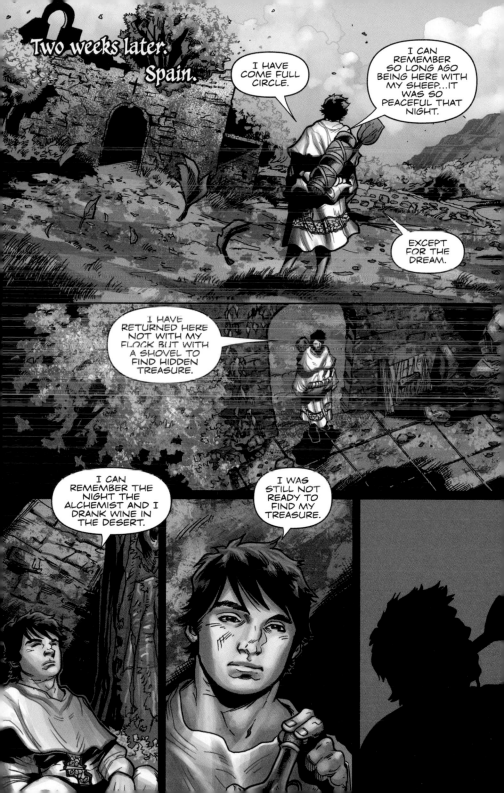

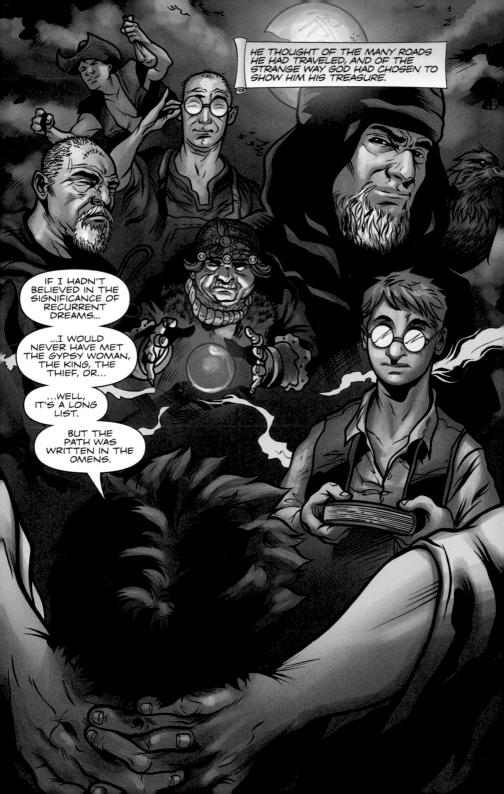

THERE WAS NO WAY I COULD GO WRONG.

THE BOY FELL ASLEEP WITH THOUGHTS OF HIS JOURNEY ON HIS MIND.

The next morning.

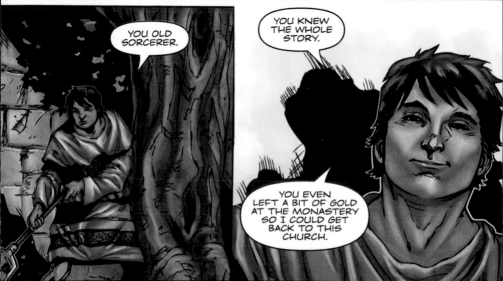

YOU OLD SORCERER.

YOU KNEW THE WHOLE STORY.

YOU EVEN LEFT A BIT OF GOLD AT THE MONASTERY SO I COULD GET BACK TO THIS CHURCH.

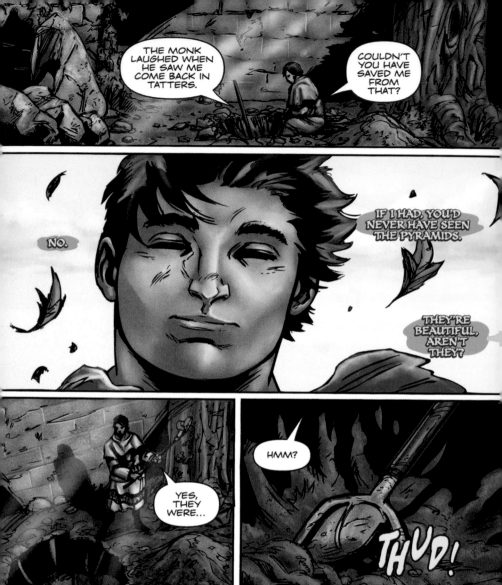

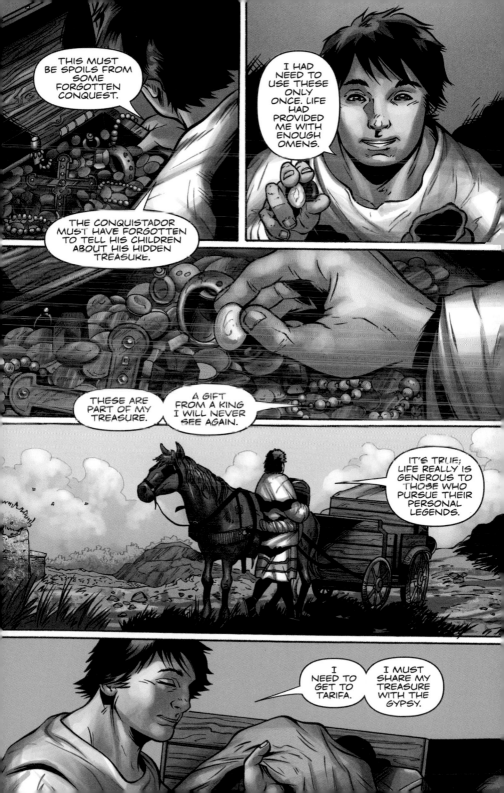

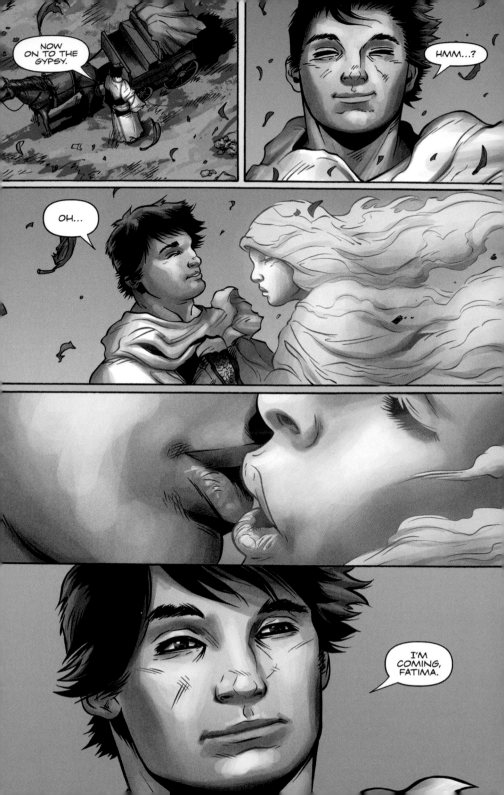

Spanish Boy

English Man

Fatima

Leader of the Oasis

General Blue Soldiers

Narcissus

Goddess 1

Goddess 2

Santiago

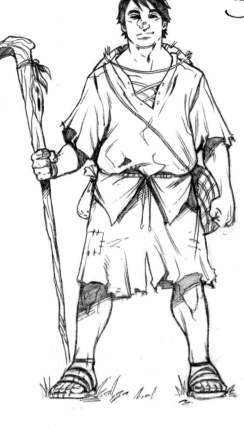

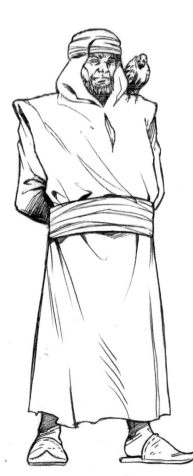

The Alchemist

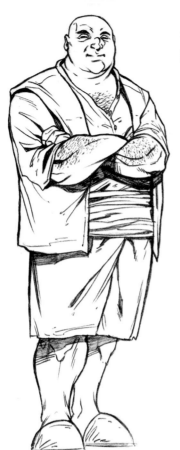

Merchant

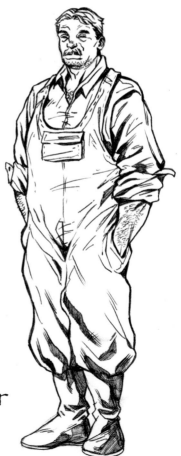

Santiago's Father

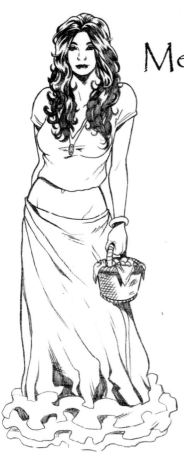

Merchant's Daugther

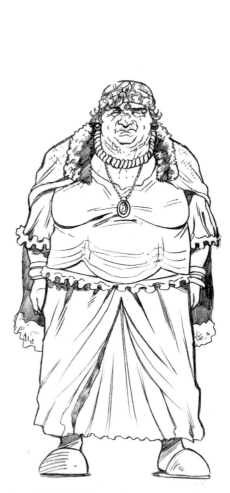

Gypsy

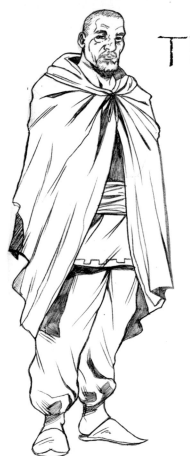

The King of Salem

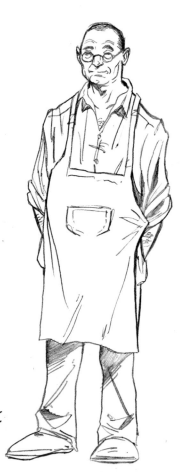

Crystal Merchant

2021

6-12